VIRGINIA
BEACH
SHIPWRECKS

VIRGINIA BEACH SHIPWRECKS

ALPHEUS CHEWNING

THE
History
PRESS

Published by The History Press
Charleston, SC 29403
www.historypress.net

First published 2008

Manufactured in the United States

ISBN 978.1.59629.474.5

Library of Congress Cataloging-in-Publication Data

Chewning, Alpheus J., 1954-
Virginia Beach shipwrecks / Al Chewning.
p. cm.
Includes bibliographical references and index.
ISBN 978-1-59629-474-5 (alk. paper)
1. Shipwrecks--Virginia--Virginia Beach--History. 2. Shipwrecks--Virginia--Atlantic
Coast--History. 3. Shipwrecks--Chesapeake Bay (Md. and Va.)--History. 4. Virginia
Beach (Va.)--History--Anecdotes. 5. Atlantic Coast (Va.)--History--Anecdotes. 6.
Chesapeake Bay (Md. and Va.)--History--Anecdotes. 7. Virginia Beach (Va.)--History,
Naval--Anecdotes. 8. Atlantic Coast (Va.)--History, Naval--Anecdotes. 9. Chesapeake
Bay (Md. and Va.)--History, Naval--Anecdotes. I. Title.

F234.V8C49 2008
910.9163'47--dc22
2008035270

Notice: The information in this book is true and complete to the best of our knowledge. It
is offered without guarantee on the part of the author or The History Press. The author
and The History Press disclaim all liability in connection with the use of this book.

To Carol: my compass, my rudder and the wind in my sails.

Contents

CONTENTS

Part IV: War

Part V: Flotsam and Jetsam

Acknowledgements

Writing about history is very different from writing fiction. You don't have to create believable characters, develop a story line or conceive some devious plot. Essentially, you're collecting information and putting it together to tell a story about an event that actually happened. Many times it's a story that is well known, so as a writer, you simply look for one bit of new information (ideally from a primary source) and add that to the retelling.

I would like to thank Richard Pouliot and his wife Julie for giving me so much to work from. Their book, *Shipwrecks on the Virginia Coast*, which chronicles shipwrecks from 1878 to 1915, was an inspiration and an invaluable resource.

I must also thank the reporters, the diarists and the individuals who filled out the countless report forms, who have unwittingly preserved these stories of struggle, courage, life and death—these stories of history.

Thanks to my friends who listened over and over again to these stories and who provided insight by adding tales of their own experiences of being aboard ship.

Introduction

I've been very fortunate to have spent most of my life around water. I grew up in the Thalia area of Virginia Beach, and our house backed up to Buchanan Creek. When I was nine years old, I would take our boat out to Lynnhaven Bay, Broad Bay, Linkorn Bay and Crystal Lake. There was a submerged wreck just outside of Lynnhaven Inlet that we all knew as the "pirate ship," and I used to go diving for it. Diving for me meant holding my breath, swimming to the bottom, about five feet, and groping around in the murky water. I had my hands all over cannons and anchors, but that's not what I wanted. (It's a good thing, too, because my boat was only an eight-foot johnboat.) All I was looking for was that proverbial chest filled with treasure.

When I was twelve, my grandfather died and my father bought the family estate on Urbana Creek. For the next several years, we'd spend our summers there. There weren't many kids my age up there, so I spent a lot of time out in our new boat, a sixteen-foot Glaspar runabout with a seventy-five horsepower outboard. I would travel all over the Rappahannock River, alone, at age fifteen. That's how I met Walter Cronkite. I had taken the boat to Stingray Point, and he had run his sailboat aground in the same area. I pulled him off the sandbar and he was smiling. I think he was happy because there were no adults with me to witness his situation. For me the experience was a revelation. Now I understood how ships became shipwrecks.

My father couldn't afford to keep two houses, so we sold the one in Urbana and he bought a sailboat. It was a twenty-four-foot Westerly Centaur and he named it *Aeolus*, after the mythical god of the sea winds. I didn't like sailing with him, but on occasion he'd let me go out with just a couple of my friends, and we'd go to Tangier or Urbana or Deltaville. During one of these weekend excursions, I had another moment of truth. Caught in a sudden squall, I realized I might experience a shipwreck firsthand.

Eventually I was able to buy my own boat. It wasn't much—an eighteen-foot Wellcraft bow rider, but it was my pride and joy. I named it *Gypsy* because when I was with it I didn't have a care in the world, and it could take me anywhere I wanted to go. *Gypsy* and I would go fishing or diving out at the light tower or on one of the local wrecks, but now diving involved scuba tanks and all the other equipment; and no, I didn't go diving alone.

I think my favorite memory of *Gypsy* was the afternoon my golden retriever Saffron was out with me and a pod of dolphins swam by. I shut off the engine and we drifted. The dolphins were all around the boat, and Saffron was standing at the bow with her head over the side, watching them. The dolphins came within four feet of her. They'd roll onto their sides and swim slowly past, looking up at her—I swear they were communicating.

I had *Gypsy* for about eight years before I lost it. The boat wasn't wrecked like the *Titanic* or even the SS *Minnow*. Actually, it wasn't a wreck at all. It burned up with several hundred other boats at a dry storage marina. After that, I never got another boat of my own, but I got something even better. After twenty-one years in the fire department, I was assigned to Virginia Beach's first fireboat. Needless to say, my experiences there gave me yet another perspective on maritime emergencies.

The closest I ever came to finding actual treasure was one morning when my wife and I were walking Saffron on the beach. Lying right on top of the sand was a clay pipe about seven inches long. It was the kind of pipe you see at Colonial Williamsburg. It was so pristine that I assumed it was a fake, but an appraiser estimated it was from the late seventeenth or early eighteenth century. I called John Broadwater, the state archaeologist at the time, and he told me several people had reported similar finds that same day. We concluded that an old cask

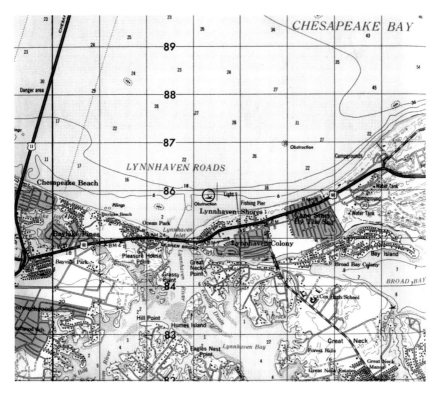

This chart shows the area around Lynnhaven Inlet. The circled icon of the half-sunken sailboat indicates the location of the "Lynnhaven Wreck." By all estimates, it's over two hundred years old, but it has never been identified. *Courtesy of the author.*

or crate lost overboard two hundred years ago was packed with these pipes, and a recent storm must have uncovered them. I personally think it was from the wreck of HMS *Swift* in 1697.

Over the years, there have been two serious attempts that I know of to recover that wreck near Lynnhaven Inlet. One was in 1994, and several cannons of different sizes were removed from the site. In 2003, Hurricane Isabel exposed the wreck again so the Army Corps of Engineers got rid of it for good. They didn't dig up any significant artifacts, but there was still one cannon left. It was five feet one inch long with a muzzle ten inches across and a bore of three and one-fourth inches. Since nobody's ever been able to identify it, in my mind it will always be the "pirate ship."

Part I
The Eighteenth Century

The New Eden

In 1969, the State of Virginia introduced an ad campaign that is still in use today and has become one of the most-loved and most-recognized slogans in the tourist industry. The four simple words, "Virginia is for Lovers," were designed to bring people to the state to visit and/or live. It was aimed at everyone who is a "lover"; lovers of flowers, lovers of the ocean, lovers of the mountains, etc. At its conception, the slogan was hailed as "brilliant," "exciting" and "new."

In the early 1730s, William Byrd II started a similar campaign to bring people to Virginia. For several years, Byrd corresponded with the leader of a Swiss community, urging him to move to Virginia. In 1737, his book, *Neu-Gefundenes Eden*, was published in Switzerland. *The New Found Eden*, written in German, described in great detail the advantages of living in Virginia.

Byrd, born in 1674 in Charles City County, Virginia, was sent to England, the land of his father, at age seven. There he was educated in law and served as a member of the King's Counsel for thirty-seven years. He then returned to Virginia and inherited his father's estate at Westover Plantation. He had become a prolific writer and eventually amassed a collection of approximately four thousand books, the largest library in the colonies.

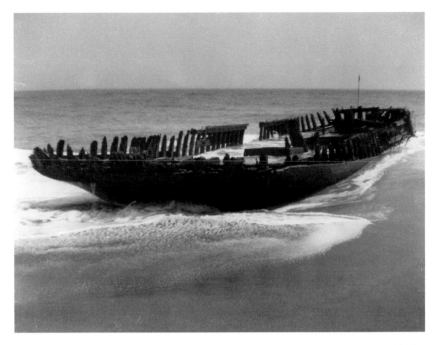

This unknown wreck in Virginia Beach was uncovered by a violent storm, probably the same type of storm that caused the wreck in the first place. *Courtesy of the collection of the Old Coast Guard Station.*

In 1728, Byrd was chosen to lead a group of Virginians to survey and settle the disputed boundary line between the colonies of Virginia and North Carolina. To Byrd, Virginia was far superior to its southern neighbor. Not only was Virginia the first English colony in North America, but it was also a royal colony. North Carolina was owned by a group of Lords Proprietors. It was very important to Byrd to separate the two territories, not only physically, but socially as well.

In June of 1735, the executive council of Virginia in Williamsburg granted Byrd ownership of 100,000 acres of land along the Roanoke River, with the stipulation that the land be settled by at least one family for every 1,000 acres before the end of two years. An extension of this deadline was later granted.

Byrd began corresponding with one of the leaders of a Swiss group that showed interest in coming to America. In his letter to John Ochs, Bryd wrote that the "honest, industrious" Swiss Protestants were much more welcome in Virginia than "the mixt people that come

from Pennsylvania." He invited Ochs's people to settle in the Roanoke River Valley, where the mountains "are exceedingly rich and the air perfectly wholesome." He promised fertile fields where "any grain you please" will grow in abundance, rivers where the water is "clear as crystal" and abundant streams to operate any kind of mills. He even intimated that living in Virginia increased his sexual potency. It was, after all, the new "Garden of Eden."

After a few years, Byrd's sales pitch worked, and John Ochs agreed to bring his little colony to Virginia. Byrd sold him a tract of thirty-three thousand acres, and in early August 1738, the group left Plymouth, England, bound for Virginia. The name of the ship is not recorded. The number that set sail is not known for certain. The *Virginia Gazette* of January 12, 1738, reports in one paragraph "a ship with about 500 Switzers," but in another paragraph in the same story refers to "the 300 souls that entered on board." In either case, it was a very crowded journey. There was little room for cargo, and most of the settlers had sold their possessions and carried with them only their most valuable treasures.

A normal Atlantic crossing in those days might haven taken six to ten weeks, depending on the winds and the experience of the crew. On November 24, 1737, the *Virginia Gazette* reported that from a vessel

> *lately arrived at Hampton, from Pennsylvania, we have advise, that a Ship sail'd about thirteen weeks ago, from Plymouth, with a considerable Number of Switzers on board, who are bound for this Colony, to settle here, on the Back Lands; for which Purpose Foreign Protestants have great Encouragement from this Government.*

As the months passed, many more reports came from ships arriving in Hampton. The ship bearing the Ochs settlers had been seen and in some cases communicated with. One report said the ship's captain and mate were lost and that fifty to sixty passengers, mostly children, had died from hunger and exposure. There are no reports that anyone attempted to give aid to those in such pitiable condition.

On January 3, 1738, after nearly five months at sea, the colonists' vessel passed Cape Henry about midmorning. Their final destination was only two hours farther, but the desperate souls onboard insisted that the crew drop anchor immediately so that food and water could

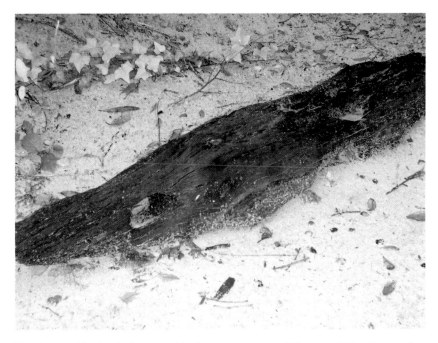

This is probably the rib from on old schooner or barque. "Treasures" like this are often found in the dunes. *Courtesy of the author.*

be collected from shore. Both a bow and a stern anchor were set, and a small boat was launched. Approximately fifteen of the healthiest men came ashore and set out to collect the necessary supplies, but after several hours of searching they had found nothing and were convinced they had landed on a small island instead of the mainland.

In the meantime, the wind, blowing from the east, had increased in strength and swung around to gust from the northwest. This was the worst-possible scenario. From that direction, the wind was blowing unfettered across the length of the Chesapeake Bay, bringing snow and freezing temperatures and pushing huge waves straight toward the anchored ship. As nightfall approached, hundreds of terrified men, women and children onboard the hapless vessel huddled together in a desperate attempt to survive the blizzard conditions.

During the night, the ship dragged anchor, was blown to shore and filled with water. Many people, already weak from hunger and the bitter cold, drowned below deck. Countless others, who were able to get off the ship, either drowned or froze to death before they reached

the shore. Their bodies, along with wreckage of the ship, were scattered along the beach for hundreds of yards, lying frozen in grotesque poses. Had it not been for the assistance of two other vessels anchored nearby, numerous others would have been found the same way.

As word spread about the tragedy, the people of Princess Anne County responded to the scene in their wagons, and men from as far away as Hampton responded in boats of all sizes. In the marshes, searchers found more bodies, often two or three together in a frozen embrace. Documents from Princess Anne County show that in the week following the shipwreck, the local sheriff was summoned to several homes along the Lynnhaven River to take charge of bodies that had washed ashore.

A few survivors were found and cared for in the homes of the local residents. Some died within a few days. The exact number of those who died is not known, nor is the number of survivors. One report says sixty survivors; another, ninety. Most of those who lived through this ordeal did eventually settle in William Byrd's "Eden." It is unknown if John Ochs was among them.

According to the *Virginia Gazette*, "The ship was reckoned to be one of the richest that has come to this colony in many years, and 'tis feared that much of her treasure is lost." A second report, printed the following week, gives only a little additional information:

> *The ship lies in a bad condition at the same place where she struck, full of water, so that they have got but little out of her yet; however, proper methods are being taken to get their money, which is said to be considerable, and goods out of her. And then they propose to go to their intended settlement.*

Part II
The Nineteenth Century

Freedom Denied

This story first ran in the *Norfolk Herald* and was picked up by the *New York Times* and published November 30, 1855. The story is not so much about a shipwreck as it is about the passengers onboard.

The *Mary Anne Elizabeth* left the docks in Norfolk, Virginia, on Wednesday, November 28, 1855, headed up to Philadelphia. That night a storm rolled through, producing gale-force winds from the northeast. The next morning, the *Mary Anne Elizabeth* was on the beach, five miles south of Cape Henry. It had lost some of its sails and rigging but was not seriously damaged.

This area of Princess Anne County was very sparsely populated, but news of a shipwreck travelled fast. Before long, a group of people had arrived on the beach to offer whatever assistance they could. There is no record of exactly how things transpired, but according to the *Norfolk Herald*, several "fugitive slaves," whose owners were known to be from Norfolk, were found onboard.

The "negros" reported that they had given the schooner's captain, William Lambden from Wilmington, Delaware, $125 to pay for their passage north. Lambden denied it, claiming he had no idea the fugitives were aboard until late Wednesday evening, when he happened to open the forward hatch and found them hiding there. He said he

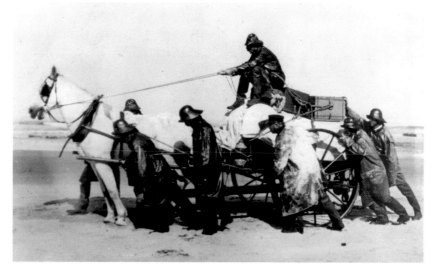

Before there were all-terrain vehicles (ATVs), this was the way the lifesavers got their equipment to the scene of a shipwreck. *Courtesy of the collection of the Old Coast Guard Station.*

made his first mate, Benjamin Collins, of Port Norris, New Jersey, aware of the situation at that time and that Collins was as astonished as he was. Lambden acknowledged he had the $125 but explained that he took it from the fugitives because he believed it was illegal for slaves to have money.

Lambden insisted that he was in the process of turning his vessel around to return to Norfolk when the storm overtook the *Mary Anne Elizabeth*, and he opted to run it aground rather than have it sink.

At some point, the sheriff or some other authority figure must have arrived on the scene because, according to the *Herald*, both Lambden and Collins were placed in a Norfolk jail for "save keeping."

The Gale of '78

Hurricanes weren't given names until 1950. Prior to that, they were simply referred to according to some significant date, place or event. For example the "Norfolk and Long Island Hurricane" (killed two hundred people in 1821), the "Galveston Hurricane of 1900" (killed ten thousand people) and the "Great New England Hurricane" (killed eight hundred people in 1938). The ninth storm of 1878, although technically a hurricane, is remembered as the "Gale of '78." It started in the Caribbean on October 17 and traveled up the American East Coast through New England on October 24. The storm was responsible for seventy-one deaths, nineteen of them in Virginia Beach. In Philadelphia, alone, more than seven hundred buildings were destroyed at an estimated cost of $2 million (at 1878 prices).

An employee of the United States Signal Service, Mr. Bolton was repairing the weather monitoring equipment at the Seatack Life Saving Station when the storm hit:

I was at the station when the gale, which proved so disastrous to human life commenced. A severe rain storm has prevailed all day Tuesday (22nd) but the gale did not reach the station until 9 p.m. It rapidly increased in velocity until it almost became a hurricane. The members of the crew at this station, whose duty it is to patrol the beach that night, performed their duties with the utmost difficulty, as they could scarcely make any headway against it, and often had to cling to some stationary object like a telephone pole to prevent themselves from being carried away at the mercy of the fearful tempest.

Out at sea, the sailing ship *A.C. Davis* was trying to get home ahead of the storm. It had sailed from Callo, Peru, for Norfolk on July 23, with a cargo of guano. At 1,400 tons, the *Davis* was a big ship and required a crew of twenty men. The master was Captain James W. Ford. After a journey of nearly ten thousand miles, *A.C. Davis* was just hours from port.

Surfman John T. Atwood was on patrol on the north side of the Seatack Station. He was forced to take shelter for a period of time when the full force of the storm made it impossible to remain on the

beach. The weather station at Cape Henry recorded a five-minute sustained gust of eighty-four miles per hour. As the eye of the storm was passing over, Atwood was able to reach the end of his patrol area and began the return trip. Halfway back to the station, he noticed shattered bits of debris from a wreck. A little farther down, the beach was littered with every type of broken board, plank and timber. The trained eyes of the veteran surfman took in every little detail, hoping to find some indication that someone might have gotten to shore alive. He noticed footprints, and he followed them into the dunes about one hundred yards. There he found William H. Minton.

Surfman Atwood escorted Minton back to the station less than a mile farther south. While most of the other surfmen went searching for additional survivors, Milton told the story of what had happened.

Shortly after midnight, with shortened sail, the *A.C. Davis* was rapidly approaching Cape Henry. Without warning, the three-masted ship ran headlong onto the beach. A following wave washed over the deck and tore away the stern. The next wave hit and literally shook the ship to pieces.

Milton had scrambled up into the *Davis*'s rigging, but he fell onto the ship's cabin and from there was swept into the sea. He somehow managed to get to shore, but he knew he couldn't survive the fury of the storm without shelter. He crawled to the dunes and buried himself in the sand, leaving only his head exposed. He had dug himself out just moments before he was discovered by Surfman Atwood. He was the only survivor.

Mr. Bolton wrote about what he observed that morning:

> *The debris was thickly scattered along the beach for a distance of fully 4 miles...I proceeded to Cape Henry, Virginia to assist the Signal Officer there. The body of one of the crew was there. About 1½ miles south of Cape Henry the bodies of eleven of the crew had been washed ashore.*

In all, seventeen of the nineteen bodies were found; many grotesquely disfigured. Captain Ford and ten of the crewmen were buried in a mass grave one and a half miles south of the Cape Henry Life Saving Station. The other five were buried just north of the wreck site.

You Don't Have to Come Back

If the first week was any indication, the winter of 1887 was going to be a tough one. Extremely cold temperatures, high winds and periodic snowstorms made working outdoors nearly impossible and, as a rule, most Virginia Beach residents remained inside the comfort of their homes. The exception to this rule were the men of the United States Life-Saving Service (USLSS). This frightful weather was exactly the kind of condition that made ships vulnerable to disaster, and the welfare of the men onboard those ships was the sole responsibility of the brave surfmen of the USLSS.

Lifesaving stations were strategically located along the coast every seven to eight miles. The Virginia coast, south of the Chesapeake Bay, was designated as USLSS District Six and was composed of five stations: Cape Henry (#1), Seatack (#2), Dam Neck Mills (#3), Little Island (#4) and False Cape (#5). From December 1 to April 30, each station was staffed by a "keeper" and six "surfmen." During daylight hours, a surfman stood watch from a tower attached to the station, or from the roof of the station if there was no tower. After dark, the men were assigned to patrol the beach. These patrols lasted for four hours and were scheduled sunset to eight o'clock; eight o'clock to midnight; midnight to four o'clock; and four o'clock to eight o'clock. If visibility was poor during daylight hours, the watches continued on this four-hour schedule.

At every station, two men would share a four-hour watch, but each would patrol alone. One man would walk the beach north of the station, and the other man would go south. Each man would travel halfway to the next station in line, where he would wait to meet up with the surfman on patrol from that station. In other words, the surfman patrolling north from station #4 would meet up with the surfman patrolling south from station #3. When they did meet face to face, they would exchange a brass check, or marker, and then each would return to his own station. Having the other man's check would indicate to the stations' keeper that the surfmen had not been sleeping or goofing off during their watches. The men would meet twice during their four hours.

On January 8, 1887, Surfman James Belanga was patrolling the beach south of the Dam Neck Mill station. He arrived at the halfway point of his patrol shortly after 1:00 a.m. and waited. Surfman George Stone, walking north from the Little Island station into the wind and blinding snow, didn't arrive for almost thirty minutes more. As the two men exchanged their markers, they became aware of a vessel in distress somewhere close by. Driven by the northeast wind, the snowflakes seemed to absorb the light given off by the surfmen's oil lanterns. They could see nothing, but they could make out the distinctive sound of canvas sails being ripped apart, and through the howling wind and crashing surf they could faintly hear the screams of men calling out in fear and desperation.

Each surfman fired a Coston flare into the sky to indicate that help was on its way. They knew that if the men onboard the stranded ship could see the flares' red glow through the blizzard, perhaps it would provide them some minimal comfort. Stone and Belanga then hurried off in opposite directions, each going to sound the alarm at his respective station. This time it was Belanga struggling headlong into the thirty-mile-per-hour wind. In spite of his best efforts, it was nearly two hours before he reached station #3, where he breathlessly made his report to Captain Barco as the other surfmen made ready to head out into the elements.

In the meantime, George Stone had returned to the Little Island station, called the surfmen to action and at approximately 3:00 a.m. that crew, under the command of James's brother, Captain Able Belanga, arrived in the area of the stranded ship. Hampered by strong winds, drifting snow and impenetrable darkness, they could do nothing. Within the hour, James Belanga and the men of station #3 arrived from the north, but were likewise frustrated by their inability to do anything. As they waited for the dawn, Captains Belanga and Barco discussed the upcoming rescue operation. Captain Belanga assumed overall command of the incident since he had arrived on the scene first. At last, near five o'clock, the sky lightened, and for the first time the surfmen could see the shadowy silhouette of a three-masted sailing ship approximately eight hundred yards offshore. The ship was the 1,200-ton *Elisabeth*.

The *Elisabeth* was built in Boston, Massachusetts, in 1855, and was christened *Empress*. It was a double-decked, full-rigged ship, 195 feet

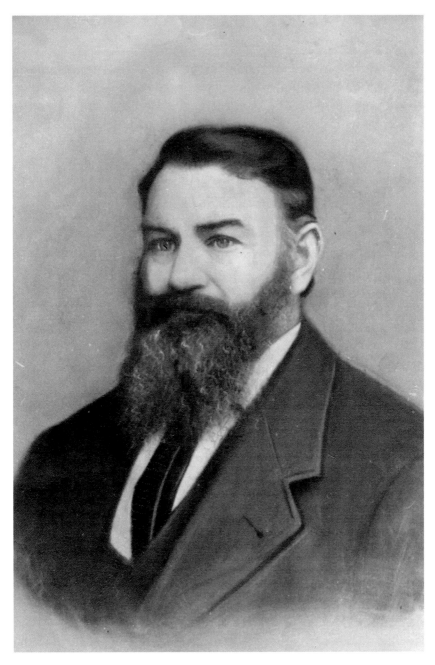

Frederick Halberstadt, captain of the *Elisabeth*. *Courtesy of the collection of the Old Coast Guard Station.*

in length and 39 feet abeam. In 1882, it was rebuilt in New York, changed owners and was rechristened *Elisabeth*, with Captain Frederick G. Halberstadt in command. Hamburg, Germany, became its home.

Frederick Halberstadt, from Bremen, had commanded the German ship *Edward* before he took command of *Elisabeth*. At fifty-three years of age, he had been a ship's master for twenty-five years, and in July 1886, he celebrated a rather notable achievement: fifty round-trip Atlantic crossings. Captain Halberstadt had made the crossing from Hamburg to Baltimore, and back, fifty times, traveling 400,000 miles, or the equivalent of sixteen times around the globe. A reception was held in Baltimore aboard the *Elisabeth* and was attended by many prominent German citizens. The ship then returned to Bremen with its regular cargo of petroleum, and on November 15, the captain and his dear *Elisabeth* set out to Baltimore for the last time.

As the sky lightened, the stormed eased a bit, and the surfmen on the beach could finally assess the situation confronting them. The *Elisabeth* was hard aground on a sandbar, broadside to the beach, its bow to the north, its deck listing toward shore. To the uninitiated, this might not sound like a dangerous scenario. After all, the ship can't sink; it's already aground. However, at this point, the *Elisabeth* was no longer a ship. A ship by definition is something designed to float on the water. Once aground it is the same as a house or barn. It will not stand up to the pounding surf, and so time became a critical issue as far as rescuing the crew was concerned.

In a situation such as this, the preferred method of recue was to get a line out to the vessel and, once done, transfer the victims to shore one at a time using what was called a breeches buoy. It was a slow but effective method that the surfmen practiced regularly, and it in no way endangered the rescuers. Only as a last resort would the surfmen launch their own boats into the ocean and venture out to the wreck.

Using the surfboat at night, in rough seas, would have been suicide. As they prepared to respond to the *Elisabeth*, Captain Belanga and Captain Barco had ordered their men to leave the rescue boats at the station. They took with them only the equipment required to set up the breeches buoy. In the darkness, using only dead reckoning, the men made two attempts to hook up with the *Elisabeth*; however, the daylight revealed the ship was well out of range of their Lyle gun.

A Lyle gun was a small cannon that fired a projectile out to a stricken ship. A light rope was attached to the projectile. The crew of the ship would pull in the light rope, to which was attached a stronger rope, and they would affix this rope to the ship's mast, thus establishing a connection to the shore.

The surfmen tried repeatedly to bring the *Elisabeth* into range by using double the normal amount of gunpowder in the Lyle guns, but after four additional attempts they were unsuccessful and out of powder. Finally, out of options, Abel Belanga sent his men back to the Little Island station to get more powder and the surfboat.

In the meantime, waves were crashing over the starboard side of the *Elisabeth*. The ship's crew managed to launch a small boat into the relatively quite water on the lee side, and all twenty-two men climbed in.

At eleven o'clock, nearly ten hours after the wreck of the *Elisabeth* was discovered, the surfboat was ready. Two additional shots were fired from the Lyle guns, but both fell short, and Captain Belanga faced a difficult task. Although the snow had stopped, not much else had improved; it was still very windy and cold, and the sea spray turned to ice in an instant. He had to pick six of the strongest, most experienced men to go with him out to the *Elisabeth*.

The men he chose—John Land, George Stone and John Etheridge from station #4, and Joseph Spratly, Frank Tedford and his own brother, James Belanga from station #3—stepped forward without hesitation. They all knew the motto of the USLSS: "You have to go out, but you don't have to come back." They also knew that they were the only hope for the crew of the *Elisabeth*.

To compensate for the wind and current, the surfboat approached from the north. It took almost an hour of brute strength and sheer determination before the surfboat finally arrived alongside the crippled *Elisabeth*. Seven of the crew, including Captain Halberstadt, climbed in with the surfmen and were given cork-filled life preservers. The others remained in *Elisabeth*'s lifeboat. Each second that passed made the possibility of surviving seem more likely. Just as the surfboat pulled away, a mountainous wave rolled over the *Elisabeth* and swamped the two small boats, dumping the twenty-seven occupants into the icy water. One boat remained tethered to the *Elisabeth*, but the surfboat quickly began drifting south.

It was a common practice to bury bodies in the sand. Some were recovered and reburied in cemeteries, but many were not. *Courtesy of the author.*

The men on shore could see a few survivors clinging desperately to the overturned boats, but they could do nothing but watch in fearful anticipation as, one by one, the men in the water succumbed to the elements and disappeared beneath the waves. Only two would survive: John Etheridge and Frank Tedford. Five of the heroic surfmen perished, along with all twenty-two men who had been aboard the *Elisabeth*.

For the remainder of the day and through most of the next, bodies washed up on the shore along a stretch of several miles. The first bodies to be recovered were from the lifesavers' boat—all were wearing the cork-filled life preservers. As the bodies were found and examined, they were pulled up the beach, beyond the high waterline, and buried in the sand. The graves were plainly marked so the remains could later be disinterred if necessary. One of the bodies was clothed

much nicer than the others and was believed to be that of Captain Halberstadt. Papers and a photograph were found that confirmed this identification.

One of the German seamen was apparently planning to take up residency upon arriving in Baltimore. The following letter was found in the dead man's pocket:

> *Bremen, November 9, 1886.*
> *Mr. Frank Shaler, 43 South Gay Street, Baltimore, Md.*
>
> *Dear Sir-*
>
> *The bearer, Edward E. Kollmann, is a good*
> *man in every aspect, and if you will assist him in obtaining*
> *employment you will confer a favor on*
>
> > *Yours, &c.*
> > [signed] *Oscar Rollig*
> > *of Rollig & Co.*

A similar letter was also found addressed to Armstrong, Cator & Company.

Captain Halberstadt's body was taken to Baltimore for burial. With the exception of the five bodies that were never recovered, the *Elisabeth*'s crewmen were given a Christian burial in Norfolk's Elmwood Cemetery.

On January 10, 1887, two funeral services were held for the deceased surfmen. John Land and his stepson, George Stone, were buried on their family's property in Pungo. Captain Abel Belanga, his brother James and his brother-in-law Joseph Spratley were laid to rest in the cemetery of a local church. The local newspaper gave this report of that day:

> *The five life-saving men who were lost were hard working men, on whom other mouths were dependent for daily bread, and were men who were much respected in their respective neighborhoods, which are all very near the vicinity of the wreck. Captain Belanga leaves a wife but no children; John W. Land leaves a wife and two children; Geo.*

W. Stone had been married only a short time, and therefore leaves only a wife to mourn his loss; Joseph Spratley leaves a wife and some family, but it could not be found out how large, J. E. Belanga leaves a wife and two children. This shows that all of the men were married, and as they had no means of support than their salary their families will be deprived of this means of support and their suffering may be almost unmeasurable [sic].

These five men unselfishly gave their own lives, not for their families or their comrades, but for strangers. May they rest in peace.

Despite attempts by the wrecking steamer *Peed*, the *Elisabeth* could not be salvaged. Its cargo of seven hundred tons of kainit (salts of potassium used in the manufacture of fertilizers) and five thousand empty oil barrels was valued at $10,000 and the value of the ship at $20,000. The losses were covered by insurance. The cause of the wreck will never be known, but it is probable that while sailing with reefed sails, trying to reach Cape Henry and the safety of the Chesapeake Bay, sufficient allowance was not made for the strong currents.

The Easter Shipwreck

In 1891, the first Sunday after the first full moon following the vernal (spring) equinox, better known as Easter Sunday, was on March 29. In the little seaside community of Virginia Beach, the Princess Anne Hotel was crowded with vacationers. The hotel's 140 rooms were almost all filled with families from up North who had come to get an early start to summer. They had come, no doubt, to witness the breathtaking sunrises and to enjoy the sea breezes that were warmed by the passing Gulf Stream. Instead, they had witnessed, indeed experienced, a tragedy that would become part of local history.

On Good Friday morning, the guests awakened to grey skies, torrential rain and fifty-mile-per-hour winds from the northeast. Most had never encountered anything like this and were awed by the strange beauty of the angry ocean. As breakfast was being served in

the dining room, the hotel manager, Mr. Crittenden, greeted everyone and encouraged them to spend the day playing games in the parlor. He then walked around and chatted individually with the visitors.

Mr. and Mrs. David Gregory were nearing the end of their three-week vacation. The Gregorys and their seventeen-year-old daughter, Emily, usually vacationed in Florida, but because Virginia Beach was so much closer to their home in New York, they had decided to give it a try. Emily, especially, enjoyed all the natural beauty of the seashore and made many new friends, including the man she would eventually marry.

As Mr. Crittenden spoke with the Gregory family, they noticed a figure on the beach, clad in rain gear and walking to the north. Crittenden explained that it was one of the surfmen from the lifesaving station just up from the hotel, returning from patrolling the beach and looking for vessels in distress. He told them that shipwrecks were not uncommon in the current weather conditions.

The Seatack Live Saving Station, USLSS #2, was built in 1878 but had changed very little over the years. One significant change was the addition of telephone service that allowed direct communication between the stations. Also, in addition to the traditional surfboat, a new piece of equipment was now kept in the stations. The life car was a short, corrugated iron tube, tapered on both ends—essentially a covered lifeboat. It was designed to rescue as many as six persons by bringing them to shore through the waves, instead of one at a time, on an aerial line, like in a breeches buoy.

At approximately nine o'clock in the morning, Captain Edward Drinkwater, keeper of the Seatack station, received a call from his counterpart, Captain Bailey Barco, from the Dam Neck Mills station, five miles to the south. Barco reported seeing a sailing vessel about a mile off the beach, heading northward with reefed sails. It appeared to be in trouble.

Immediately, Drinkwater sent a man up to the observation deck on the station's roof with the order to watch for the reported vessel. The rest of the surfmen checked their equipment and stood by at the ready. This is what they trained for and they all knew the motto. At least one of the men, George Stone, had been there when five brave surfmen had perished at the wreck of the *Elisabeth*.

About an hour later, the lookout spotted the ship passing the station. The ship was dangerously close to shore and seemed to be at

the mercy of the violent waves. On Captain Drinkwater's command, the surfmen donned their rain gear, hitched the surfboat to the mule and headed out. Drinkwater made a quick call to the Cape Henry station requesting that they respond also.

The high surf was pounding against the dunes so the mule could not go along the beach. Instead, he was led along a narrow road a few hundred yards inland, but the strong winds had blown down many trees across the road, and they had to be cleared with axes before any progress could be made. In the meantime, a few of the men, along with a group of fishermen, traveled north through the dunes so as to keep the ship in sight. As they watched, the ship shuddered and turned suddenly toward the beach. It was aground near where Fortieth Street is today.

The ship was the 191-foot Norwegian barque *Dictator*, under the command of Captain Jorgen Jorgensen. The fourteen crewmen onboard scrambled to obey their captain's order to cut away the mainmast. As soon as the rigging on the windward side was cut, the force of the wind alone snapped the mainmast off just a few feet above the ship's deck. As the heavy wooden mast collapsed and fell, it brought down the fore and mizzen topmasts as well. The loss of the *Dictator* was certain, but it might still be possible to save the crew. The ship was only 350 yards from shore, and Jorgensen could see the rescuers on the beach.

By about eleven o'clock, the surfmen had their equipment set up and fired the first shot from their Lyle gun. The plan was to get a small diameter rope out to the *Dictator*'s crew by attaching the rope to a projectile and shooting it over the ship. When the first attempt fell short, the surfmen set up for the next shot using the smallest-diameter rope they had.

In his personal account of the rescue, Surfman J.L. Robinson wrote the following:

> *We fired three times and each time the shot fell short and did not reach the ship. We had to move our gear several times as the ship was drifting down the beach. She was so far out the gun could not reach her, and too we had to fire right into the wind and it was blowing so hard the line attached to the shot held it back.*

While this was going on, the crew from the Cape Henry Life Saving Station arrived and made several unsuccessful attempts with their own Lyle gun. In addition, Mr. Crittenden and a large number of people arrived from the Princess Anne Hotel. These were the hotel guests, and although they did not understand the various complexities of the operation, they were full of comments and criticisms.

Captain Jorgensen could see what was happening on the beach, and he realized that no rescue could be made until a lifeline between ship and shore was established. The *Dictator*'s lifeboats had been destroyed when the ship's masts and rigging collapsed on them. Jorgensen ordered his first mate, Cornelius Nilsen, to tie one end of a long rope to the ship's railing and the other end to an empty barrel and then to set the barrel adrift. It wouldn't take long for the wind and waves to carry the barrel to shore. In that brief time, Jorgensen went below to his cabin to check on the condition of very valuable cargo.

It wasn't unusual for a Norwegian sailing captain to take his wife with him on long voyages. Jorgensen's wife, Johanna Pauline, had made many journeys with him, and ever since their son Carl was born in 1887, the family had traveled everywhere together. Little Carl was born, not in Norway, but in Wellington, New Zealand, and his twenty-six-year-old mother gave him the middle name Zealand in honor of his birthplace.

In his cabin, Captain Jorgensen found his wife attempting to calm their frightened six-year-old son. He explained to her that the *Dictator* had run aground, but assured her that they would all be rescued very soon. He told her to put on some of his clothing because her long woolen dress would make it difficult to move about on deck and impossible to swim in. He then returned to the main deck to oversee the set up of the breeches buoy.

The ropes were finally secured to the tallest part of the foremast, and the breeches buoy was ready to be put into use. Captain Jorgensen selected Seaman Jacob Mell to be the first man sent to shore in the canvas trousers suspended from the ropes. Things went well for the first few minutes but, just as Mell was suspended over the waves about halfway to shore, the situation changed. The wind, waves and tide caused the *Dictator* to shift from being perpendicular to the beach to being parallel to the beach. This put the ship in a position to roll with the waves—first toward the shore, then toward the ocean.

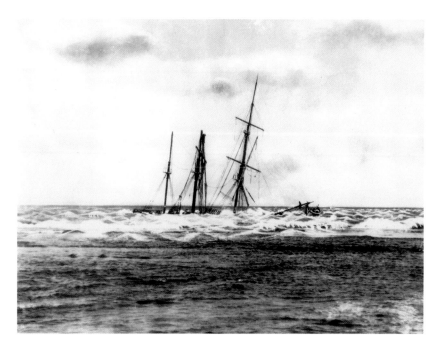

This unknown ship was in a situation similar to the *Dictator* when it was destroyed in 1891. *Courtesy of the collection of the Old Coast Guard Station.*

Poor Jacob Mell was hanging in the breeches buoy just above the wave tops. Now, every time the *Dictator* rolled toward shore, he would be ducked in the water. Then, when the ship rolled back the other way, he would pop out of the water into the air and spin around the rope. As the rope became more and more tangled, the Norwegians struggled to bring their fellow crewman back onboard the ship. It was obvious the breeches buoy wasn't going to work.

This kind of bad luck had plagued the *Dictator* since it set sail from Pensacola, Florida, on March 3. On March 12, having just rounded the Florida Keys and entering open ocean, the *Dictator* was buffeted by a fierce storm that lasted nearly two days. Then, on March 19, after passing Grand Bahama Island, it encountered a fierce tropical storm that damaged the barque and destroyed two of its lifeboats. Shortly afterward, it was determined that the *Dictator*, built in 1867, had sprung a leak. It was then that the captain discovered that the storm had also damaged the ship's pumps. Unable to repair the pumps, the crew operated them manually.

On March 23, near Bermuda, the beaten and broken *Dictator* was assaulted once again as hurricane-force winds and mountainous waves unleashed their full fury. This was too much.

Water was filling the ship at the rate of two inches per hour. The *Dictator*'s crew was exhausted and refused to work unless Captain Jorgensen turned the ship for America, where it could be repaired. What concerned the captain the most were the rumors aboard ship that all this trouble was because of his lovely Johanna. Sailors have long believed that a woman onboard a vessel is bad luck.

It was supposed to be such an easy trip from Florida to West Hartlepool, England. There, the cargo of pine would be unloaded and used to make the masts and spars of new ships. Then Captain Jorgensen would take the *Dictator* home to Moss, Norway. Jorgen and Johanna had decided, now that Carl was six years old, that he should start attending school. So, arrangements had been made for mother and son to live in Norway while the captain finished out his career. Now all that would have to wait.

The captain turned his ship due westward for the shipyard in Norfolk, Virginia. Although the storm did ease up, it seemed to follow the *Dictator* for the next three days. The heavy clouds prevented the usual methods of navigation, leaving Jorgensen only his compass to guide him. As a result, when land was sighted in the early hours of March 27, Captain Jorgensen did not know his exact position.

Using dead reckoning, Jorgensen knew he needed to turn the ship north to reach the entrance to Chesapeake Bay. Then, after rounding Cape Henry, all would be well. Unfortunately, False Cape was mistaken for Cape Henry, and before anything could be done, the *Dictator* was wrecked, the breeches buoy couldn't save them and there were no lifeboats.

Then Captain Jorgensen remembered that there was another small boat onboard the *Dictator*. It wasn't much, just a work boat to allow the men to do work around the *Dictator*'s hull while anchored, but it just might work.

The boat was launched with great difficulty. Four men climbed down into it. As the men began to row for shore, a rope tied to the boat's stern was played out from the deck of the *Dictator*. So far, Captain Jorgensen's plan was working flawlessly.

If and when the men made it to shore, they were to ascertain whether the surfmen were planning to launch their own surfboat to

attempt the rescue of those still on the *Dictator*. If so, the men were to walk north along the beach and wave their hats as a signal to Captain Jorgensen that help was on the way.

If the surfmen were not going to use their surfboat, the four Norwegians were to find a long rope, tie it to the bow of their own little boat and then walk south along the beach and wave their hats so Captain Jorgensen would pull the boat back to the *Dictator* and use it to ferry the others to shore (much like the intended use of the life car).

The little boat was about halfway to shore when it was swamped by the high waves, and the four men were dumped into the ocean. Four surfmen immediately waded out into the violent surf and assisted the men to the safety of the beach. In their excitement, the Norwegians forget their orders and no signal was ever sent back to Captain Jorgensen.

It was now about one o'clock in the afternoon, and from the four rescued sailors it was learned that the wrecked ship was the *Dictator* and that there was a woman and her child onboard. Onlookers demanded that Drinkwater launch the surfboat. Captain Drinkwater determined that even under the command of his highly trained surfmen, no boat could be launched from the beach in the present conditions. It was too great a risk. Emotions boiled with anger, frustration and fear. Surfman J.L. Robinson remembers:

> *The beach was lined with people (guests) from the Princess Anne Hotel all day. I heard one man say, "Get out the boat and I will go." That man was from the hotel. He just did not know what he was talking about. He had on a long coat and a quart bottle was sticking out of each pocket. What was in the bottles I could not say, but they looked like quarts of whiskey.*

By three o'clock, the tide had subsided, and Captain Drinkwater decided to try the rescue again using the breeches buoy. This time, Jacob Mell was successfully brought ashore, and the breeches buoy was returned to the *Dictator*. The ship's carpenter was next and he, too, was brought to shore. As the rescue apparatus was being pulled back out to the ship, Captain Jorgensen brought his wife and son up on deck for the first time. He intended for her to be the next one sent ashore.

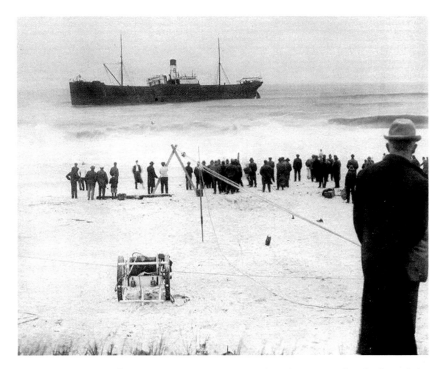

This picture, taken of a wreck in the 1950s, shows that sixty years after the loss of the *Dictator* people still gathered and the breeches buoy was still in use. *Courtesy of the collection of the Old Coast Guard Station.*

With the *Dictator* literally breaking up under him, Jorgensen somehow got Johanna up into the rigging, but she panicked, became hysterical and absolutely refused to get into the breeches buoy. As Captain Jorgensen patiently assisted his wife back to the main deck, two other men were rescued via the buoy.

By late afternoon, each wave that broke over the ship's deck pulled something loose. The stern was gone. The poop deck had collapsed. Then, with a thundering crack, the *Dictator* broke in two and the bow section fell away. Now it was every man for himself.

Cornelius Nilson, the second mate and one seaman clambered forward to the jib boom. A man named Saint Clair, the ship's steward, climbed up the mizzenmast. Captain Jorgensen, his wife by his side and his son in his arms, stood bravely on the angled poop deck, hoping it would break free and carry his family to safety. Two other sailors trusted the captain's judgment and waited with him, but one of them,

Ole Olsen, lost his nerve and jumped overboard in an attempt to swim for shore. In spite of being a very good swimmer, Olsen drowned.

It soon became apparent that the poop deck was not going to break away as hoped, and it was now too dark to see the beach. Captain Jorgensen embraced his wife and told her not to give up, that they would still swim to safety. Johanna started to cry and told her husband she thought it would be better to die all together, where they were.

The captain tied a life ring around Johanna's waist and another one around his own. He then lashed little Carl to his chest. He planned to throw the ship's ladder into the water, jump in after it and bring it alongside the ship's hull. Then, Seaman John Baptiste would lower Johanna down over the side and into the water. Together, using the ladder as a raft, the captain and Mrs. Jorgensen would paddle safely to shore.

Jorgensen threw the ladder in according to his plan, but after that, nothing went as expected. When Jorgensen jumped into the sea, he missed the ladder and was carried away from the ship by the current. He and Carl were bashed about among the wreckage and then driven to the sea bottom by a crashing wave; when the captain surfaced, he realized his son was gone, torn from his body.

Johanna Pauline was washed overboard by a large wave. John Baptiste immediately went to her aid, but in spite of his efforts, they both drowned.

To those who watched from the beach, darkness meant the end of hope. There was nothing to be done. The lifesaving crew from the Cape Henry station returned to their quarters. The men of the Seatack station built a huge fire on the beach and continued to patrol, looking for possible survivors. They found the second mate, tired but able to walk. Then they found Captain Jorgensen, weak and heartbroken over the loss of his son.

Surfman J.L. Robinson wrote about finding Captain Jorgensen:

> We had a cart on the beach and we put him in this cart. Four men and myself pulled him to our station in this cart. When we reached the station it was between ten and eleven o'clock that night. We put dry clothes on him, and he gave me his watch and said to me please put some oil in it. I noticed it stopped a little after eight o'clock, and that must have been when he let himself down in the water.

When Captain Jorgensen was brought into the Seatack station, he was met and consoled by the other nine survivors of his ship. Then it grew very quiet, and soon all of them lay down on their cots and fell into an exhausted sleep.

The next morning, the sun rose in a clear, blue sky. The wind had diminished, but the surf was still rough. The *Dictator* was gone, completely destroyed. The beach was littered with wreckage and cargo. Huge pieces of pine timber, sixty to eighty feet long and twelve inches square, were piled up like pickup sticks, completely blocking passage in some places. Two surfmen were patrolling, looking for bodies.

As the rest of the surfmen were busy getting their equipment back in service, Captain Drinkwater interviewed the survivors and notified the Norwegian consul of their situation. Throughout the day, three bodies were recovered and brought to the station. Two were found by a surfman on patrol from the Cape Henry station. Another body washed ashore in the vicinity of the wreck. Surfman J.L. Robinson remembers a conversation between Drinkwater and Jorgensen:

> *Captain Drinkwater said to him, "Captain Jorgensen, let's take a walk on the beach." His reply was, "No, Captain, I cannot go. I might see my wife or boy washed up on the beach, and I could not bear to see that. I just could not bear to see their bodies."*

Some of the survivors ventured out onto the beach to help search for their shipmates and perhaps to recover some personal mementos. Also on the beach were local fishermen, salvagers, sightseers and the guests from the Princess Anne Hotel. Mr. Crittenden, the hotel's manager, was out in his buckboard, giving Miss Emily Gregory a tour of the area. As she looked out to sea, she noticed a large shape rolling in the surf directly in front of the hotel. Mr. Crittenden investigated and found it was the massive figurehead of the *Dictator*. He dragged it up to the wooden boardwalk and it immediately attracted a crowd.

The figurehead became known as "the Norwegian Lady" and became a very popular tourist attraction, pictured on postcards, pennants and other souvenir items. In 1906, it was damaged by fire when the Princess Anne Hotel burned to the ground. Over the years, several attempts were made to restore the local icon, but all succumbed to the effects of wind and weather.

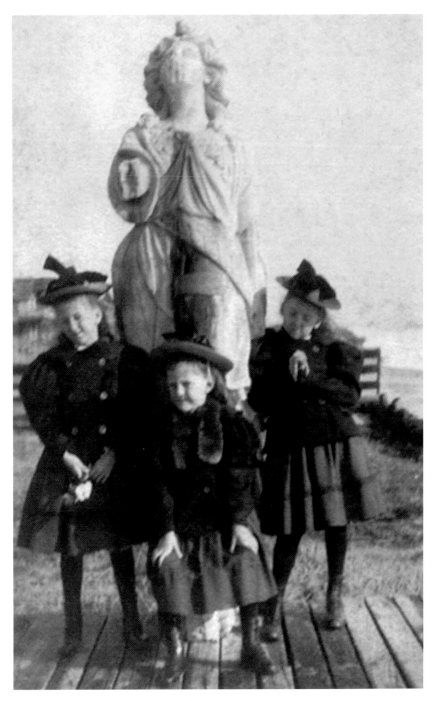

Three young ladies pose beside the original figurehead of the Norwegian barque, *Dictator*. *Courtesy of the collection of the Old Coast Guard Station.*

In August 1953, as Hurricane Barbara appeared and headed for Virginia Beach, the figurehead was carefully taken down and wrapped for storage. For one reason or another, it was forgotten until 1960. When workers went to get it, they realized it was lost. It was replaced with the current statue made of bronze on September 22, 1962. The statue was set at the end of Twenty-fifth Street, as there were plans to make that the new entryway to the resort area. By coincidence, the new Princess Anne Hotel had been constructed at the intersection of Twenty-fifth Street and Atlantic Avenue.

On Easter Sunday 1891, the bodies of John Baptiste and Johanna Pauline Jorgensen were found in the surf near the Princess Anne Hotel. The only bodies that remained missing were those of the ship's steward and the captain's son.

On March 31, funerals were conducted in Elmwood Cemetery in Norfolk, Virginia. The news coverage of the tragic shipwreck brought hundreds of mourners to the services, and the area was adorned with wreaths and flowers sent from all over the world. The six sailors were buried on a lot belonging to the Seaman's Friend Society. A Norfolk restaurant owner, Joseph Klepper, donated a private plot for the burial of Mrs. Jorgensen.

On April 3, Captain Jorgensen and the rest of the survivors boarded a train bound for New York. There, they would return to Norway by ship. Before leaving Norfolk, Captain Jorgensen visited his wife's grave. Kneeling, he offered a tearful prayer and gathered a handful of flowers that he would keep as a sentimental token of his sweet "Paua."

Also on April 3, the body of a black man washed ashore near the Seatack Life Saving Station. It was determined to be that of Saint Clair, the *Dictator*'s steward. Saint Clair was buried in a Virginia Beach cemetery.

The next day, Surfman J. Burlas was on patrol and passing by the Princess Anne Hotel when he saw something in the shallow water a few yards offshore. He waded out and gently picked up the tiny body of Carl Jorgensen. Cradling the body in his arms, Burlas slowly returned to the station to make his report. The undertaker was notified and Carl was buried next to his mother that very afternoon.

The United States Life-Saving Service initiated an investigation almost immediately after the loss of the *Dictator*. At issue was whether

Captain Drinkwater had done everything possible to rescue the people aboard the Norwegian vessel. The investigation received national attention when an anonymous letter appeared in the *New York Evening Post* absolutely berating the USLSS for every action taken in the attempted rescue.

In the end, it was decided that Drinkwater was correct in not launching the surfboat that day. However, he was found at fault for not returning to the station and getting the life car, the new device made specifically for storm conditions. Sumner Increase Kimball, general superintendent of the Life-Saving Service, signed a letter on April 20 calling for the dismissal of Captain Edward Drinkwater. Drinkwater's resignation was effective May 4, 1891.

Jorgen Jorgensen returned to Norway and was offered a job as captain of a small ship, but he declined the position. He returned to his hometown, changed his name from Jorgensen to Donvig and designed Captain Donvig's Life Saving Globe, a revolutionary device. He traveled around the world, promoting his new invention and using his own story of the *Dictator* to illustrate its usefulness. He displayed his globe at the 1900 World's Fair and won a design award, but unfortunately, Donvig was too much of a visionary and his invention was years ahead of its time. No one was interested.

In 1904, Donvig remarried but suffered serious financial trouble. He took a job as a lighthouse keeper in 1907, but couldn't tolerate the boredom and resigned in 1912. He took a job as first officer aboard the Norwegian steamship *Pennsylvania*. He signed on using the name Jorgensen since all his records and licenses were under that name.

As Jorgensen stood on the bridge of the *Pennsylvania* on Friday morning, January 3, 1913, a terrible storm reminded him of that fateful day aboard the *Dictator*. However, in addition to the wind and waves, now there were freezing temperatures and fog. The *Pennsylvania* was heading very slowly down the Chesapeake Bay from Baltimore.

At approximately eleven o'clock, the *Pennsylvania* was approaching Tangier Island when the ship's lookout spied a vessel in distress and alerted the captain. The ship was the British steamer *Indrakuala*, adrift and showing heavy damage to its bow. There were two lifeboats in the water nearby.

The *Pennsylvania* approached the lifeboats and prepared to take them aboard, but the sailors in the first lifeboat explained that they

were not rescuing men from their own ship, but from another one that had sunk about two miles to the south and that the *Pennsylvania* was desperately needed there.

Around nine o'clock, the *Indrakuala* had collided with the much smaller *Julia Luckenbach* and nearly broke it in two. The American *Luckenbach* sank in only two minutes, with eleven souls trapped below decks, unable to escape. One was the captain's wife. Captain H.L. Gilbert survived the collision but drowned trying to save his wife.

The *Luckenbach* went down in fifty-five feet of water. Sitting on the bottom, its masts and smokestack were still about six feet above the waves. Six men had been rescued and taken onboard the *Indrakuala*, but in its damaged condition it was unable to remain in the area. Ten other survivors were in the water. One man drowned when he tried to scale the smokestack. The other nine clung desperately to the mastheads.

The *Pennsylvania*'s master, Captain Lessner, brought his ship to within a mile of the sunken *Julia Luckenbach*. The strong winds and towering waves prevented him from getting any closer without endangering his own ship. He asked for volunteers to row out in a lifeboat to attempt to rescue the nine crewmen from the sunken steamer. Jorgen Jorgensen stepped forward.

With waves washing over the deck of the *Pennsylvania*, Jorgensen and four others got into a lifeboat and were, with great difficulty, lowered over the side. Because of the severity of the storm, it took an hour to get to the stranded sailors. The *Luckenbach*'s chief engineer, Christopher Knugsen, overcome with cold and exhaustion, lost his grip and drowned within a few yards of his comrades.

After several attempts, Jorgensen was able to get a line over to the men on the wreckage, and the lifeboat was tied off. While two men bailed and the other two struggled to maintain the stability of the small boat, Jorgensen tied a buoyant life ring and began his rescue efforts.

It took another hour to get the eight men into the lifeboat and equally as long to return to the *Pennsylvania*. In the meantime, the captain of the *Indrakuala* beached his ship to prevent it from suffering the same fate as the *Luckenbach*. Captain Lessner headed for Newport News, but when the *Pennsylvania* arrived there, the sea was too rough—the ship anchored overnight and docked the next morning.

The eight survivors lauded the courage of the man who had saved them from certain death. Jorgen Jorgensen insisted that he was only doing his job. On March 27, 1891, seven souls were drowned when Captain Jorgensen's barque, *Dictator* was wrecked. On January 3, 1913, he saved eight men from the same fate.

Forty-year-old Frederick R. Hunt, the first mate of the *Julia Luckenbach*, kept local reporters spellbound with his detailed story of the incident. This was not the first time he had survived a shipwreck. In 1905, Hunt and his father were on a ship that wrecked at Cape Henry. Hunt's father did not survive.

Another historic storm occurred around Easter 1962. For five days, it lashed the eastern seaboard, killing more than thirty people, injuring more than a thousand and destroying $200 million worth of property. It is referred to as the "Ash Wednesday Storm," and until Hurricane Isabelle in September 2003, it was the costliest and deadliest storm in Virginia.

Despite all the destruction caused by the 1962 storm, there was one piece of debris left behind that actually excited everyone. In the dunes

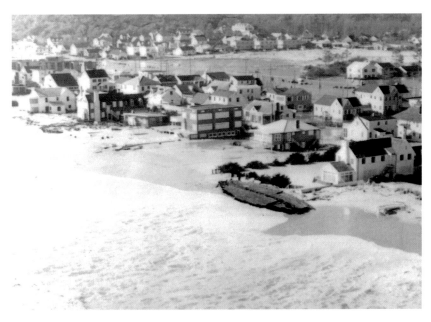

The remains of the *Dictator* uncovered by the Ash Wednesday Storm of 1962. *Courtesy of the collection of the Old Coast Guard Station.*

near the end of Sixty-first Street, two huge pieces of a shipwreck had been uncovered. Even though they were found almost a mile north of where the *Dictator* had gone aground, many people believed that these were its remains.

Experts examined the wreckage and determined that the construction was of the type used in the mid- to late nineteenth century. Analysis of the wood indicated that it was the type used by the shipyard in New Brunswick in 1867. The measurements were the same as those of the *Dictator*. It had been found at last, but would not be recovered. The owner of the property where the wreckage was found quickly grew tired of all the activity and hired a bulldozer to cover the *Dictator* with sand once again.

The Honeymoon Cruise

Just after midnight on April 7, 1889, a surfman on the north patrol returned to the Seatack Life Saving Station and sounded an alarm: "Ship ashore. To the north! She's close!"

The other surfmen donned their foul-weather gear and swung open the big doors in front of the breeches buoy apparatus. Even through the driving rain, they could see a dark, towering hulk less than one hundred yards up the beach. The water was up to the dune line so the men had to approach the grounded vessel from the backside of the dunes. Nevertheless, they arrived on the scene very quickly.

The ship was the *Benjamin F. Poole*, a four-masted centerboard schooner built in 1886. The *Poole* was on its way from Providence, Rhode Island, when it beached trying to enter the Chesapeake Bay. Because it was in ballast (carrying no cargo), the extremely high tide carried it far up on the beach, its bow to the north.

In less than ninety minutes, the *Poole*'s first mate and eight crewmen had been brought to shore by use of the breeches buoy. After looking over the ship and realizing that it was in no danger of breaking up, the first mate was hauled back over to the *Poole*, where he joined the ship's master, Captain Hjalmar Charlton.

While the surfmen from the Seatack station were involved in assisting the *Poole*, the schooner *Emma F. Hart* came ashore just a few miles to the north. Unable to control the vessel in the high winds, the *Hart's* captain anchored offshore to wait out the storm. The anchor could not hold fast on the flat, sandy bottom and the *Hart* was blown ashore.

The men from the Cape Henry station responded to the *Emma F. Hart* and safely rescued the captain and crew by means of the breeches buoy. The *Hart* was a total loss.

At about the same time, another ship was driven ashore by the weather. The two-masted schooner *Northampton* had been adrift since losing its anchor near Cherrystone on the Eastern Shore the previous day. As the small oyster boat drifted past Cape Henry and entered the open ocean, its captain, Elijah Lawson, ordered the three crewmen to cut the masts away. The ship was carrying no cargo, and Lawson hoped this action would prevent the little schooner from capsizing.

As the *Northampton* drifted to the south, the waves washed over its decks and quickly swamped it. The captain and two of the crew were washed overboard about two hundred yards from the beach. The third crewman remained with the vessel until the very last moment and jumped into the water just before it broke to pieces.

All of this happened about three miles south of the Seatack Life Saving Station, but because everyone was at the other two wrecks, the *Northampton* wasn't discovered until ten o'clock in the morning. The surviving seaman, John Moody, supplied the details of the sinking.

The bodies of the two crewmen who went overboard were never found. Captain Lawson's body was discovered several days later, ten miles south of where his ship went ashore.

A few days later, when the storm had passed and the tides were back to normal, the *Benjamin F. Poole* was high and dry. Even at mean high water, a person could walk completely around the ship without worrying about getting his feet wet.

The Merrit Wrecking Company was hired to refloat the 1,155-ton *Poole*, but without success. It was apparent that since a flood tide brought it in, it would take a flood tide to take it out, so a sort of dry dock was built around it and the ship was secured with heavy ropes.

To abandon the vessel would make it possible for salvagers to claim it so the captain and most of the crew remained in Virginia Beach and took turns staying onboard the *Poole*.

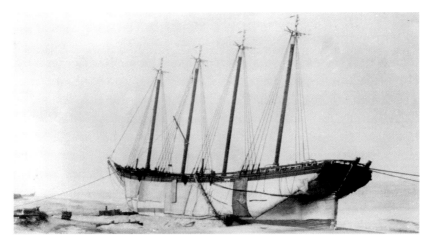

The *Benjamin Poole*, the honeymoon suite for Captain and Mrs. Charlton. *Courtesy of the collection of the Old Coast Guard Station.*

Captain Charlton and his men became rather well known in the town, and many friendships developed over the next fifteen months. In fact, Captain's Charlton's friendship with one young lady developed into love and the two were married in July 1890.

What new bride wouldn't want to spend her honeymoon in a nice, secluded love nest, overlooking the ocean? Well, Captain and Mrs. Charlton did exactly that, in the captain's lavishly appointed cabin at the *Benjamin F. Poole* hotel.

For the next two months, the Charltons lived aboard the *Poole*, enjoying celebrity status. All their meals were prepared by the ship's steward and every day countless tourists would come visit their beached bungalow. Unfortunately, all good things must come to an end, and on September 28, 1890, the *Benjamin F. Poole* was refloated during a northeast storm that lasted for three days.

The *Poole* was towed to a shipyard, where it was overhauled and eventually returned to service.

Unfortunate Consequences

Built in 1854 at the Gosport Naval Shipyard in Portsmouth, Virginia, the USS *Constellation* is the second United States warship to bear that name. The original frigate was launched in 1797, and the name is representative of the constellation of stars on our country's new flag. Ironically, the first *Constellation* was in the Gosport Shipyard being disassembled at the same time its replacement was being constructed. Classified as a sloop of war, or corvette, at 184 feet in length it is the largest ship of its class and the last all-sail warship built for the U.S. Navy.

Prior to the American Civil War, the *Constellation* patrolled off the coast of West Africa as the flagship of the U.S. Africa Squadron. Its mission was to enforce the 1808 law that prohibited the importation of slaves to the United States. This mission continued after the start of the war, but in the summer of 1862, the *Constellation* was relocated to the Mediterranean, where it hunted for Confederate commerce raiders. With sixteen eight-inch guns, four thirty-two-pdr long guns, three twelve-pdr boat howitzers and a rifled Parrott gun on the bow and stern, the sloop of war was a formidable vessel. In 1864, it joined Admiral Farragut's blockading squadron in the Gulf of Mexico.

In 1871, the USS *Constellation* was designated as a training ship for the United States Naval Academy, and over the years, thousands of midshipmen trained aboard it. Many of these men would go on to become high-ranking naval officers. Because of this, the *Constellation* earned the nickname "Cradle of Admirals." Providing unique training opportunities, the sloop of war was used to transport priceless American artwork to the 1878 Paris Exhibition, and in 1880, it carried foodstuffs to relieve the famine in Ireland.

One special activity was the annual summer cruise for the instruction of the First, Third and Fourth Classes. The Second Class was left behind and received hands-on training in machine shops. The cruise usually began the second week of June, and the first week was spent with the *Constellation* anchored in Lynnhaven Bay. By the end of the third week in June, the sloop of war passed through the Virginia Capes and spent the next month cruising along the Atlantic Coast. Some years it would sail north to Portsmouth, New Hampshire, and sometimes south to the West Indies. By the end of August, it would be back in the Chesapeake Bay and docked in Baltimore soon afterward.

On June 15, 1889, the USS *Constellation*, with Commander P.F. Harrington in charge, left Baltimore for the typical summer excursion. This year the ship's compliment consisted of 135 cadets, 170 sailors (or "blue jackets"), 14 officers, 15 marines and 30 servants—a total of 364 men. At 3:00 p.m. on June 18, in heavy rain and thirty-mile-per-hour wind, the *Constellation* went aground in Lynnhaven Bay, approximately three hundred yards from the beach. One of the ship's officers was sent to shore in a small boat to get assistance. Unfamiliar with the area and not knowing that the Cape Henry Life Saving Station was less than a mile distant, Lieutenant Archer made his way almost twelve miles into Norfolk to report the incident.

Although the lifesaving stations closed on May 1, they remained occupied by the keepers. When Keeper Johnson of the Cape Henry station heard from a local fisherman about the stranding of the *Constellation*, he responded to the scene with a few volunteers and, with the help of the sailors who had brought Lieutenant Archer to shore, he managed to get a breeches buoy set up in the event it was needed. It was not.

Fortunately, by late afternoon, the winds had calmed considerably, and the threat to the *Constellation* was reduced. During the night, several tugs and salvage vessels arrived, and shortly after the noon hour the next day the great sloop of war was pulled out into deeper water. Nearly one hundred people had gathered along the shore to watch the spectacle. There appeared to be little damage, if any, but the ship was taken to Norfolk to be inspected.

Although Lieutenant W.F. Low was the *Constellation*'s navigator, the responsibility for the accident was put solely on Commander Harrington—one of the unfortunate consequences of being in command. One month later, Harrington was facing a court-martial before Secretary of the Navy Benjamin Franklin Tracy. Tracy had just been appointed to his position in March of 1889. As a brigadier general in the Union army, Tracy was awarded the Medal of Honor for his actions at the Battle of the Wilderness on May 6, 1864.

Commander Harrington was found guilty of negligently allowing a vessel of the United States to become stranded and was sentenced to a two-year suspension. Earlier in his career, Harrington was in command of the USS *Dale* when it collided with the merchant ship *Grinnell* in New York Bay. Harrington had immediately relieved the officer of

Secretary of the Navy Benjamin Franklin Tracey was awarded the Medal of Honor during the American Civil War. *Courtesy of the National Archives.*

the deck of all blame and took upon himself the responsibility for the accident. Later, a court of inquiry exonerated him of all charges.

Again, in 1913, when the USS *Constellation* was anchored in the Lynnhaven Bay, it dragged anchor and ran aground, but at that time it was no longer the navy training ship and very little attention was given to the event. In 1955, at one hundred years old, it was retired in Baltimore, Maryland, where it underwent a renovation costing $9 million that was completed in 1999. The USS *Constellation* is now on public display at Baltimore's Inner Harbor, where all four decks are open for exploration, allowing a glimpse into life aboard a sailing ship in 1860.

Part III

The Twentieth Century

Heroes

To work in a profession where the motto is "You have to go out, but you don't have to come back" was not for the faint at heart. The surfmen of the United States Life-Saving Service were a unique breed of men and every one a hero. However, two local men received very special recognition for their individual actions in the line of duty. Bailey T. Barco and William N. Capps were each awarded the USLSS Gold Life-Saving Medal, given only to those few who demonstrate extraordinary heroism by putting their own lives at risk to save others.

The story of Bailey Barco's medal begins when the three-masted schooner, *Jennie Hall*, sailed from Port-of-Spain, Trinidad, on November 12, 1900. Captain Daniel Lamson and his crew of six expected to arrive in Baltimore with their cargo of asphalt in time to celebrate Christmas with family and friends. Shortly after leaving Trinidad, a stowaway, Ben Mall, was discovered onboard and was given duties and responsibilities in order to earn his keep.

The passage was quiet and uneventful until December 2, when bad weather befell the vessel and continued for the next three weeks. The crew worked continuously to repair the sails, which were repeatedly damaged by the high winds, until the foresail and topsail were

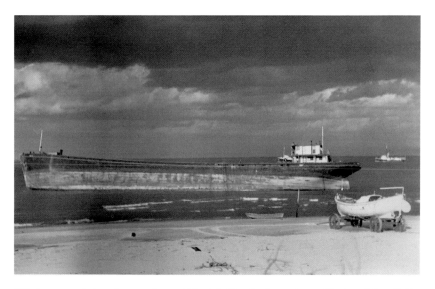

What appears to be a barge ashore at Virginia Beach after a storm. *Courtesy of the collection of the Old Coast Guard Station.*

completely blown away. The *Jennie Hall* was utterly at the mercy of the sea, and the heavy cloud cover made celestial navigation impossible.

On the morning of December 19, the frail 412-ton schooner passed close by the Diamond Shoals Lightship at Cape Hatteras, North Carolina, and was able to take on much-needed provisions. According to the first mate of the *Jennie Hall*, its crew had been without food, except bread, for ten days. Then the schooner proceeded north for the remainder of the day, and by nightfall the winds slacked, although only briefly. At midnight on December 20, the winds were thirty-five miles per hour from the northeast, and the *Jennie Hall* was barely making headway along the Virginia coast. At approximately 4:00 a.m., someone onboard reported seeing a light off the port bow, possibly the Cape Henry Lighthouse. Captain Lamson ordered a course change and cautiously proceeded to the west, but the light must have been from a nearby house because by 4:30 a.m. the *Jennie Hall* was aground on a sandbar about a quarter mile north of the Dam Neck Mills Life Saving Station, twelve miles south of Cape Henry.

The vessel was heavy with its load of asphalt and quickly began to break up. Without making any kind of distress, the crew hurried up into the rigging. The captain and the first mate, Benjamin Bragg, made

an attempt to salvage the ship's papers and a few personal items, but quickly retreated from the icy water. Mr. Bragg said later in an interview that Captain Lamson seemed to give up at this point and made only a halfhearted effort to climb the rigging. Bragg grabbed the captain's coat collar and tried to assist him, but a wave crashed over them and pulled Lamson from his grip. For the next hour and a half, the six crewmen and Mr. Mall clung to the mast of the *Jennie Hall*, unaware of their location.

At dawn, the shipwreck was spotted by Surfman John Carroll, who immediately reported it to Keeper Barco at the lifesaving station. Barco called the Seatack station for assistance and then proceeded with his crew to the scene, arriving there in about half an hour. He found the *Jennie Hall* head on to the beach, about three hundred yards out. Its sails were in shreds except for its mainsail, which still filled and pushed the schooner closer to shore on each wave. The sea conditions were too dangerous for the surfboat so the breeches buoy was set up to rescue the crew. Because the *Jennie Hall* was facing the beach, it presented a very small target for the Lyle gun, and it took four attempts to successfully get a line out where the ship's crew could manage it. The freezing temperature and the exertion proved to be too much for two of the men in the rigging. Seaman John Johnson and Ben Mall both fell into the ocean and were never seen again. The ship's steward, Fred Percival, was also exhausted, but to avoid suffering the same fate as his shipmates he tied his feet to the rigging and slumped down between the crosstrees before losing consciousness.

Soon, the lifesavers from the Seatack station arrived, and after all the equipment was set up, the breeches buoy was sent out and two men climbed in together. They were quickly pulled into shore and the buoy was sent out again. Benjamin Bragg, nearly unconscious, was assisted into the breeches buoy by Seaman Richard Coombs and was brought in by the surfmen, followed shortly after by Coombs. Coombs told Keeper Barco that one man, Percival, was still onboard the *Jennie Hall*. Surfman John O'Neal immediately volunteered to be sent out to the schooner to put Percival's unconscious body into the buoy. He rode the buoy out, but was unable to free Percival's body from the rigging, himself suffering the effects of the numbing cold, so he was pulled back to shore by his fellow surfmen.

Keeper Barco sent back to his station for the surfboat and asked for volunteers to go out to the wreck for the purpose of rescuing Mr. Percival.

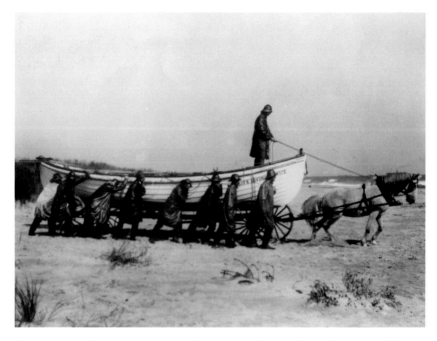

Getting the surf boat to the scene could take time. *Courtesy of the collection of the Old Coast Guard Station.*

When the boat was ready, Surfmen O'Neal and Horatio Drinkwater (a former surfman) stood at the bow while five other surfmen pulled the oars and Keeper Barco manned the steering oar. They very quickly reached the shipwreck and O'Neal and Drinkwater got onboard. Barco intended to remain and carry everyone back in the surfboat, but the wind was blowing at fifty miles per hour and the waves were washing over the small boat. Surfman John Sparrow was washed overboard by one such wave and the surfboat was pushed fifty feet away from the *Jennie Hall.* When Sparrow rose to the surface, he was battered by debris in the water but managed to reach a safety line and pulled himself back into the boat.

Keeper Barco would not endanger his men any longer and returned to the beach. There, he anxiously paced back and forth while his two men worked to get Seaman Percival free from the rigging and into the breeches buoy. In addition to being unconscious, Fred Percival was a rather large gentleman and it took a great deal of effort to effect his rescue, but it was done and then the two surfmen were also brought in via the breeches buoy.

Captain Lamson's body was recovered by a surfman at the Little Island Life Saving Station on December 22, 1900. The bodies of Ben Mall and John Johnson were never found. The *Jennie Hall*, valued at $15,000, was a total loss, as was its cargo of asphalt valued at $1,000.

On October 7, 1901, Keeper Bailey T. Barco was awarded a Gold Life-Saving Medal for his "exemplary courage, fortitude, and initiative in this valiant rescue, despite imminent personal danger." Surfman John Woodhouse Sparrow, the surfman who was washed overboard and nearly drowned, received the Silver Medal.

On January 15, 1904, Surfman Walter N. Capps proudly received a Gold Medal for "his heroic conduct in saving two men from drowning off Virginia Beach, VA." He was assigned to the Seatack Life Saving Station when he single-handedly saved two crewmen from the schooner-barge *Ocean Belle*.

On October 8, 1903, the *Richmond*, an oceangoing tug, left Newport News, Virginia, bound for the city of New York. It had in tow two schooner-barges, the *Georgia* and the *Ocean Belle*, each loaded with several thousand tons of coal. The *Richmond*'s captain was hoping to beat the storm that had been developing, but shortly after exiting the Chesapeake Bay, he realized that was not going to happen. All night he sailed north into the wind, only to find at morning's light that his ships had made no headway and were, in fact, just east of Cape Henry. He signaled to the captains of the schooner-barges to anchor, and they would all wait out the storm.

That day, October 9, the storm continued to build, and the three anchored vessels rode it out without a problem, until that evening, when the *Georgia*'s anchor cable broke and it went adrift. The *Richmond* raised anchor and went after the *Georgia*, but due to the darkness and the rough seas it was unable to gain control. The *Georgia* went ashore near the Seatack Life Saving Station and was a total loss. Its captain and crew were rescued.

By the next morning, the storm had grown to hurricane strength, and the *Ocean Belle* was on its own. Mountainous waves crashed over the deck and eventually the *Belle*'s own anchor cable parted, putting it at the mercy of the wind. Barely afloat, it ran up on a sandbar about one mile offshore and immediately started to break up. In less than an hour, its deckhouse and foremast were gone. Its master, Captain Adams, and the four-man crew hung on for dear life. The force of the

A telegraph sent by Keeper Partridge, reporting a ship in distress on Christmas Eve. *Courtesy of the collection of the Old Coast Guard Station.*

wind and the waves were pushing the *Ocean Belle* closer to the beach, but it would not hold together much longer. Captain Adams lost his hold and was washed away. The remaining men knew they would face the same end if they did nothing, so they decided to swim for shore.

A surfman on beach patrol saw the wreck and returned to the Seatack station to give the alarm. Keeper John Partridge knew that the weather conditions would cause great delay in getting equipment to the scene two and a half miles to the north, so he dispatched Surfman Walter N. Capps to run ahead and look for survivors. About half a mile up the beach, he saw a man struggling in the surf and immediately went to his aid. He helped the man to stand and then led him into the dunes approximately two hundred yards to an area of shelter. Having been told by the man that there were others in the water, Capps ran back to the beach and continued searching.

A mile farther north, Capps saw another man. He was one hundreds yards out and appeared to be dead. After removing his rain gear, boots and outer clothing, Surfman Capps waded out to recover the body. While he was pulling the man to shore, a wave broke over them and drove Capps to the bottom. He recovered and managed to

pick the body up in his arms and carry it to a sheltered area behind the dunes. There he applied the "Service method of resuscitation" for twenty minutes until the man was recovered. Then, barefoot, half-naked, nearly frozen and completely exhausted, Walter Capps led the rescued back to the lifesaving station. Along the way, they met up with Keeper Partridge and the rest of the surfmen, who had already found the first man Capps had rescued.

Back at the station, Keeper Partridge gave Capps a drink of whiskey from the first aid box and praised him as a hero. The bodies of the other two crewmen were never found. The body of Captain Adams washed ashore two days later about two miles south of the station.

The Once-Proud Ship

Unlike the schooners, brigs and barques that are considered coastal traders, the *Henry B. Hyde* was a deep-water trader, closely related to the famous clipper ships. Ships like the *Hyde* were built to haul bulk cargo over long distances. The type of material commonly carried by these vessels included granite, coal, grain, lumber and other nonperishable items.

The *Henry Hyde* was constructed in Bath, Maine, and launched on November 5, 1884. At 290 feet long and 2,583 tons, it was the largest ship ever built in that state. Although a wooden ship, it was braced throughout with two hundred tons of iron supports. It had three towering masts and was fully rigged with square sails, staysails and jibs.

The *Hyde* was perfectly suited for trading between Atlantic ports, San Francisco and the Pacific Islands. It was sturdy and reliable in all weather. The usual trip from New York, around Cape Horn, to San Francisco took an average of 124 days.

In February 1904, the big ship was en route from New York to Baltimore to receive a cargo of coal. For logistical reasons, the *Hyde* was being towed by the tug *Britannia*. The tug's master, Captain Dunn, planned to take the ship south through the Atlantic, into the Chesapeake Bay and then northwest to Baltimore. Onboard the *Hyde*

was its captain, Fred Pearson, a partial crew of thirteen men and the captain's wife.

On the night of February 10, off the Virginia Capes, a blinding snowstorm prevented Captain Dunn from seeing the Cape Henry Lighthouse. About two hours later, with the strong northeast wind driving the two vessels dangerously close to shore, Dunn released the cable connecting the tug to the *Henry Hyde*, and the mighty ship was stranded in the shoals two and a half miles south of the Dam Neck Mills Life Saving Station.

Aboard the *Hyde*, there was a foot of snow on the deck and the rigging was covered in ice. The crew somehow managed to fire an emergency rocket flare, and all were elated when they saw a similar red glow on the beach. They knew it was a signal from a surfman and that help was on the way.

Keeper James Woodhouse and the men from the Dam Neck Mills station arrived about 2:00 a.m. and found the *Henry Hyde* to be 250 yards offshore. They quickly set up the Lyle gun and fired a line out to the ship, but it was too dark and too icy for the *Hyde*'s crew to climb into the rigging. They would have to wait for daylight.

First light came at four o'clock. The surfmen were anxious to accomplish this rescue and return to the warmth of the station, but there was no activity aboard the *Henry Hyde*. After waiting in the wind and snow for another three hours, Keeper Woodhouse ordered another line fired out to the ship. The shot landed squarely amidships, and the ship's crew immediately made the line secure in the rigging.

Due to the proficiency of the lifesavers, everyone was safely removed from the *Henry Hyde*, including Captain Pearson's wife, who didn't hesitate a second before climbing into the breeches buoy. Arrangements were made to transport everyone back to Baltimore, but the ship's first mate, Frank Rhodes, remained at the lifesaving station until the storm had abated in order to evaluate the condition of the *Hyde*.

When the waiting was over, the *Henry Hyde* was found to be solidly grounded and all efforts to tow it out failed. The ship's owners determined there was nothing to be done so the ship was abandoned. Four months later, another inspection was done and the *Henry Hyde* still displayed the strength and quality for which it was known. There was a hope that it might be refloated during a higher-than-average tide that was expected to accompany the next full moon.

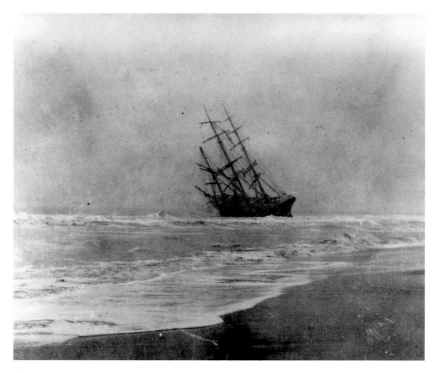

Possibly the last picture ever taken of the *Henry B. Hyde. Courtesy of the collection of the Old Coast Guard Station.*

The ship's owners hired a four-man crew to go onboard and other workers who would push, pull, dig or whatever else they could do in the sand. On the night of June 10, as anticipated, the tide did come in enough to cause the *Hyde* to tilt and lean, groaning the entire time like only a nineteen-year-old ship can do. The four crewmen panicked, thinking the ship was breaking up. They sent for the men of the Dam Neck Mills station to recue them.

For the remainder of the summer, the *Henry B. Hyde* lay out on the beach like so much flotsam. The once-proud ship was now nothing more than a curiosity. On September 21, 1904, another attempt was made to salvage the *Hyde*. This time it was successfully towed out to deep water, but the towline broke and the ship drifted back onto the shoals. Once again, the lifesavers used the breeches buoy to rescue the eight-man crew. On October 4, 1904, its long suffering ended when the *Henry B. Hyde* finally broke in two.

1906

By the early twentieth century, people were becoming accustomed to the sight of steamships parading along the coast with plumes of smoke issuing from their smokestacks. It was a sign of the times and proof that man could overcome any obstacle, even nature. Shipping was no longer dependant on trade winds and prevailing currents. Man could now sail whenever and wherever he chose. While it is true that "modern" ships, with their improved designs and better control, were less dependant on the weather conditions, they were no less vulnerable to them.

On March 31, 1906, the Virginia Beach oceanfront was being pounded by heavy seas and forty-mile-per-hour winds from the northeast. The Italian barque, *Antonio*, about a mile offshore, was sighted by the lookout at the Cape Henry Life Saving Station. The 495-ton barque was trying to round the cape, but it was apparent it wouldn't make it. The surfmen hoisted a signal flag to warn the *Antonio* of the impending danger, and the barque tacked and changed course, but by doing so it lost the wind and began to drift stern first toward the shore.

As the barque drifted past the station, the surfmen took their apparatus cart and followed along on the beach. Almost by the time the *Antonio* was aground, about two miles to the south, the men of the U.S. Life-Saving Service were ready with their breeches buoy and the rescue of the eleven souls onboard the ship took place quickly and without incident. The seamen were housed in the Cape Henry station, and the surfmen made four additional trips out to the stranded vessel to recover personal items belonging to the *Antonio*'s captain and crew.

The *Antonio* proved to be hard aground and there was nothing to be done to salvage it. Within a few days, it began to break apart. There had been no contact from the ship's owners in Castlemare, Italy.

It wasn't long before the *Antonio*'s crewmen, still housed in the lifesaving station, began to clamor about their unpaid wages. One night, a heated argument over this issue got a bit out of hand and a fight broke out. The fight escalated into a free-for-all, and the surfmen had to call for the police to help break it up. The angry sailors were

locked in individual rooms in the old station house that was being used as a storage building.

The next day, the deputy U.S. marshal was summoned from Norfolk and arrived to process the sailors' applications for compensation. The law allowed for the federal government to libel the vessel if the wages were not paid. Then the deputy marshal's job was to secure a libel notice to *Antonio*'s mast and post a watchman onboard until the owners complied with the notice.

Never before in the history of the port of Norfolk had a libel notice been served on a ship that was breaking to pieces in the surf. The Cape Henry surfmen ferried Deputy Miller out to the ship in their surfboat, and he nailed the libel notice to the mast. Due to the circumstances, a watchman was not left onboard.

The *Antonio*'s owners never did respond to the libel notice, probably because the amount in question was only $208 (approximately $26 per sailor). To settle the crew's claims, the *Antonio*'s hull was stripped of its copper sheeting and the copper was sold for salvage.

The 977-ton steamship, *George Farwell*, was passing the coast of Virginia Beach in dense fog on October 20, 1906. It was transporting a cargo of 575,000 board feet of lumber from Jacksonville, Florida, to New Haven, Connecticut. It had been battling the weather for the past ten days and had burned every last piece of coal it had. Now, without power, the *Farwell* was helpless. The steamer's master, Captain Chisholm, was making arrangements to use the cargo as fuel.

At 7:15 p.m., the surfman on lookout at the Cape Henry Life Saving Station reported that he saw a light through the fog—too close, he thought, to be safe. A red Coston flare was fired into the air to warn the unseen vessel of its danger. Nelson Holmes, the captain of the lifesaving station, sent two of his men out on patrol to better assess the situation.

Approximately two miles south of the station, the surfmen discovered the *George Farwell* stranded on a sandbar, 250 yards off the beach. They fired a second Coston flare, and Holmes immediately ordered the remainder of his men to take the apparatus cart to the scene. Before joining them, Holmes notified the Seatack Life Saving Station of the emergency and requested their assistance.

Gale-force winds, thick fog and flood tide made the rescue operations extremely difficult. At one point, the hauling lines for the breeches buoy became so tangled as to be unusable, and the work was delayed

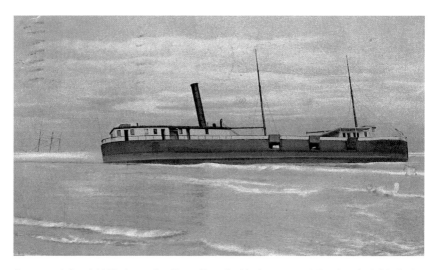

A postcard dated 1907 shows the *George Farwell* with the masts of the *Antonio* visible in the background. *Courtesy of the author.*

until daylight. It took a full twenty-four hours to safely remove all sixteen souls from the wrecked *Farwell.*

Wreckers began working on the 182-foot ship as soon as the storm passed. The cargo, valued at $125,000, was saved with little difficulty, but attempts to salvage the *George Farwell* did not go well. On October 28, sixty-six-year-old Captain William Cooley of the Merritt and Chapman Wrecking and Derrick Company died while working on the stranded steamer. According to the *New York Times,* Captain Cooley was considered one of the "most widely known wreck masters in the world."

Originally a Great Lakes steamer, this was actually the second time the *Farwell* had undergone salvage work. In 1899, the steamship caught fire near Montreal, Canada. It had just been purchased by the Manhattan Transportation Company and was taken from the Great Lakes to be used in the Atlantic coal trade. The loss, which was covered by insurance, was valued at $50,000. The *Farwell* was repaired and returned to service the following year.

This time, there would be no repair. Cape Henry, Virginia, would be the final resting place of the *George Farwell.* It became a local landmark and tourist attraction until it finally broke to pieces. Its boiler is on display at the Old Coast Guard Station Museum in Virginia Beach.

He Went Down With His Ship

After taking on a cargo consisting of 9,003 tons of iron ore and 30 tons of bagged cocoa beans, the SS *Mormackite* departed Victoria, Brazil, on September 25, 1954, bound for Baltimore, Maryland. The Moore and McCormack Company had been in the steamship business since 1913, and its first contract was to deliver a load of dynamite from Wilmington, Delaware, to Brazil. Since then, the company had grown to include five passenger liners and dozens of cargo vessels visiting ports all around the Atlantic. The *Mormackite* was built in 1945 and was 439 feet long and 6,193 gross tons. Its master was Patrick J. Mahon, and it carried a crew of forty-seven men.

The journey north was uneventful until the morning of October 7, 1954, when the *Mormackite* was off the Virginia/North Carolina coast. About 5:00 a.m., the sea condition began to get rough and waves were breaking over the bow. The ship's speed was reduced, the lookout was shifted from the bow to the flying bridge and all loose items on the deck were secured. During this time, the first mate reported that he heard the cargo "groaning" every time the *Mormackite* rolled to its port side.

The ship continued slowly northward until 9:00 a.m., when a wave struck the starboard bow "like a great hammer" and the vessel took on a perceivable list to port. Its speed was reduced once again, and at least two fire hoses were put into use to flood starboard cargo holds and thereby level the ship. At 9:15 a.m., the engines were completely stopped. By this time, the *Mormackite* was listing about twenty-five degrees, with water up to its deck and entering one of the port-side cargo hatches. The ship continued to lean until 9:30 a.m., when, with water pouring down the smokestack, the *Mormackite* rolled over and began to sink by the stern. By 9:45 a.m., it was gone.

No command was ever given to abandon ship or even to prepare to abandon ship. There were two seventy-man lifeboats on the ship, one on each side, but they couldn't be launched because of the angle. Most of the crew, wearing cork-filled life jackets, simply walked down the sloping deck and into the water. No distress flare or rocket was

ever fired and no radio message had been sent. While in the water, the radioman said he had sent a message, but an investigation would discover that no message was ever received.

For the next thirty-two hours, the men floated and waited. There were many small groups and they were scattered all around. Some of the men had found bits of flotsam to cling to—a ladder, a barrel, etc. At least one man was attacked by a shark. They didn't realize that the ship hadn't even been reported overdue until 3:53 p.m. on October 8. That's when an agent from the Moore-McCormack Lines contacted the Coast Guard, Fifth Naval District, and a search was initiated.

Two radar-equipped Coast Guard aircraft and six U.S. Navy planes were dispatched to the last-known position of the *Mormackite*, but they returned to their bases by 9:00 p.m. In addition, all vessels in the area were told to report any information as to the whereabouts of the missing ship. Three Coast Guard cutters were sent to Cape Henry, where they would begin to search the anticipated course of the *Mormackite* at dawn the next morning.

At 2:20 a.m. on October 9, the SS *Mackadonia*, at a location off the coast of Virginia Beach, radioed a report that voices had been heard in the water and boats were being launched to search. Two planes were immediately sent to that location to drop flares to assist the *Mackadonia*, and a radio broadcast the new details to all vessels. The *Mackadonia* picked the first survivor out of the water at 7:28 a.m. after he was spotted by a plane. The USS *Eaton* (DD-510) arrived soon after and rescued four men.

The search continued all day with help from Coast Guard surface vessels and aircraft, naval surface vessels, aircraft, blimps and merchant vessels. A total of eleven survivors and twelve bodies were recovered. The search continued on October 10 with three vessels, one airplane and two blimps, but nothing was found. The search was called off at five o'clock that afternoon.

The loss of the *Mormackite* and its cargo was valued at $1.55 million. It was determined that the twelve men whose bodies were recovered died from drowning or exposure. Twenty-five bodies were never found, and those men are presumed dead. Of the eleven men who survived, not a one was an officer, so there was never an explanation as to how and why things happened as they did. The

official inquiry into the sinking of the SS *Mormackite* found that Captain Mahon was negligent in allowing the ship's cargo to be loaded in such a way that it could shift, for not ordering preparations for abandoning ship and for not ordering the radio operator to send a distress signal. After interviewing all the survivors, it was also determined that Captain Mahon had not evacuated, but had gone down with his ship.

Ship Happens

The USS *Valcour* (AVP-55) was commissioned at the Puget Sound Naval Shipyard on July 5, 1946, and placed under the control of Commander Barnet T. Talbott. Following its shakedown cruise, it was assigned to the Atlantic Fleet and operated from several locations, tending seaplanes of the Fleet Air Wings until 1949. In August of that year, *Valcour* was designated as flagship for the Commander, Middle Eastern Force (ComMidEastFor). Following two cruises in the Middle East region, the *Valcour* returned to Norfolk on March 15, 1951.

On the morning of May 14, 1951, the USS *Valcour* left Hampton Roads and headed out for open water to conduct independent ship exercises. Slightly ahead of the seaplane tender was the SS *Thomas Tracy*, a Liberty-type collier leaving Newport News bound for New York with a cargo of coal. The sky was clear and the sea calm. Once past the Cape Henry Junction buoy, the collier changed course from ninety degrees to eighty-two degrees and continued at a speed of ten knots. About five minutes later, the *Valcour* altered its course from ninety degrees to seventy-five degrees and increased its speed to fifteen knots. At this time, the *Valcour's* officers estimated they were about half a mile astern of the *Tracy*.

The navy ship crossed diagonally across the stern of the *Tracy*, passing approximately a quarter of a mile off that vessel's port quarter. Without warning, the USS *Valcour* lost all electrical power. The ship's helmsman immediately reported loss of steering, and the rudder

indicator showed a seven-degree right-rudder angle. With no other way to communicate his situation, the commander sounded four short blasts on the steam whistle.

The *Valcour* actually had four diesel-powered electric generators. There were two in engine room number one and two in engine room number two. As was standard procedure, when the *Valcour* left Norfolk that morning, both generators in engine room number one were operating—one as a primary and the other as a back-up. As the ship passed Fort Wool, shortly after leaving the pier, a request was sent from the engine room to the bridge for permission to shut down one of the generators. Permission was granted. An hour or so later, a sailor, working the switchboard, noticed a drop in the generator's electrical frequency. His attempts to resolve the problem caused the circuit breaker to trip off, and then, acting on his own and without direction, the sailor shut down the generator, leaving the *Valcour* with no electrical power.

Aboard the *Thomas Tracy*, the captain heard the signals from the *Valcour* but took no action because he thought the navy vessel was conducting some kind of drill. After observing the *Valcour* for another minute or so he realized that something was wrong and ordered full reverse on the collier's engines. Then he sounded the general alarm and ordered hard right rudder to try to avoid the *Valcour*'s arcing right turn. Less than a minute later, the *Tracy*'s bow made contact with the seaplane tender's starboard side. The hole in the *Valcour* went from eight feet below the waterline to the boat deck, with about a seven-foot penetration. In addition, an aviation fuel tank had been ruptured.

Several sailors on the *Valcour*'s quarter deck were engulfed in flames when the gasoline ignited. As thousands of gallons of flaming liquid spilled out into the ocean, the entire starboard side of the ship was quickly enveloped in fire. Although the *Thomas Tracy* had managed to back away slightly, its bow was on fire and the flaming gasoline on the water was burning the paint on its starboard side. Both ships' fire teams were bravely at work onboard, and the flames aboard the *Tracy* were soon brought under control, but the situation on the *Valcour* was deteriorating. Its master, Captain Eugene Tatom, gave the order to abandon ship. Most did so by jumping into the water off the port side.

The Coast Guard cutter *Cherokee* was about a mile behind the *Valcour* when the collision occurred and quickly lowered boats to rescue the

men in the water. Once that was accomplished, the cutter went along the port side of the *Valcour* and initiated firefighting efforts. After arriving on the scene, the submarine rescue ship *Sunbird* (ASR-15) began fighting the fire from the starboard side.

In the meantime, the *Thomas Tracy* was proceeding back to Hampton Roads. It was accompanied by the navy tug *YP-282*, which pumped water into the hole in the collier's bow and extinguished the fire there. There was only one injury aboard the *Tracy*. A crewman, who had been up at the bow painting when the collision occurred, sprained his back as a result of the impact. On the USS *Valcour*, sixteen men had been injured and twenty-six killed.

After being towed back to Norfolk, the *Valcour* underwent an extensive overhaul. While under repair, air conditioning was added to the seaplane tender, but at the cost of its five-inch gun mount. No one complained. The work was completed on December 4, 1951.

For the next fifteen years, the *Valcour* rotated between the United States and the Middle East. Home ported in Bahrain from 1965 to 1971, it served as command post, living facilities and communication center for ComMidEastFor and his staff of fifteen officers. The USS *Valcour* was finally decommissioned on January 15, 1973, and ultimately sold by the navy in May 1977.

The Bridge is Out

The attack cargo ship USS *Yancey* served the United States with distinction for twenty-eight years. It was launched in Oakland, California, on July 8, 1944, and commissioned October 11 of that same year with Commander Edward R. Rice, USNR, in command.

On February 19, 1945, *Yancey* was in place off the coast of Iwo Jima, participating in the invasion of the Japanese stronghold. Two of its landing craft (LCVPs) were lost during the assault—one broached in the waves, the other was hit by enemy mortar fire. After the initial landing, the *Yancey* remained at a safe distance until the beachhead was secured.

On February 27, the *Yancey* began unloading supplies and equipment and embarking the wounded. Rough seas and the occasional mortar barrage made the work extremely difficult, and the *Yancey* itself was hit by long-range mortar fire. Fortunately there were no casualties.

After stops in Saipan and the Carolinas, the *Yancey* participated in the invasion of Okinawa, arriving eight days after the first troops were put ashore. The unloading was either done at night or shielded by a smoke screen to prevent being targeted by Japanese shore batteries, but there was little protection from the enemy air attacks. It is estimated that the *Yancey* lost a little more than fifteen hours of operational time due to air raids.

Having fought so valiantly against the Japanese, it was only fitting that the *Yancey* be present in Tokyo Bay when the surrender was signed aboard the USS *Missouri* anchored there. Afterward, it carried American occupation troops to Japan and helped bring our battle-weary veterans back home. It was assigned to the Atlantic Fleet and arrived at its new home in Philadelphia on February 27, 1945.

After a brief refit and a few months in the Western Atlantic, the *Yancey* was reassigned to the Pacific and arrived in Port Hueneme, California, on November 11 to prepare for Operation Highjump (the United States Navy Antarctic Developments Program).

Over the next ten years, the *Yancey* operated from ports all over the Pacific. In 1951, and again in 1953, it supported United Nations' military actions in Korea. Finally, *Yancey* was put out of active service in San Francisco in December 1957 and decommissioned in March 1958.

Retirement, however, didn't last long, and the USS *Yancey* was called on again in 1961 in response to President John F. Kennedy's order to strengthen the U.S. Navy. It was recommissioned in Portland, Oregon, under the command of Captain Gordon R. Keating. The *Yancey* was once again assigned to the Atlantic Fleet. This time, Norfolk, Virginia, would be its home port.

During the next year, *Yancey* took part in training exercises in the Caribbean and Western Atlantic and made one trip to Rota, Lisbon and Gibraltar before returning to Norfolk. In October, it was ordered to support the naval blockade of Cuba after it was determined that Castro's island had received nuclear missiles from the Soviet Union.

In 1965, the USS *Yancey* took onboard 593 evacuees from the troubled Dominican Republic and transported them to San Juan,

Puerto Rico, for their safety. The officers and men sacrificed their own bunks and slept on deck to provide for the comfort of the refugees. There was a unique celebration when the ship's doctor, Lieutenant Ben Passmore, delivered a baby on May 1. The son of Mr. and Mrs. Rodolfo Paez was named Stephen Yancey Paez.

After unloading its passengers in San Juan, *Yancey* returned to the Dominican Republic and repeated the operation with an additional four hundred evacuees. Only after these desparate cicvilians were safe in Puerto Rico did the *Yancey* return to Norfolk.

The *Yancey* was stationed in Norfolk for the remainder of its career and conducted training exercises with the army and marines in the Atlantic and Carribbean regions. On the afternoon of January 18, 1970, after training in the Chesapeake Bay, the USS *Yancey* dropped anchor three miles north of Little Creek Amphibious Base and 2,500 yards west of the Chesapeake Bay Bridge Tunnel (CBBT).

Completed in April 1964, after four years of preparation and an additional four years of construction, the 17.6-mile-long CBBT, between Virginia Beach and Cape Charles, is considered a man-made wonder of the world.

Nearly twleve miles of the CBBT is made up of two low-level trestles, formed by hollow, cylindrical piles, precast pile caps and seventy-five-foot-long prestressed concrete deck units. Each deck unit weighs sixty-five tons. The trestle section required 4.7 million cubic feet of concrete and twenty-nine million pounds of steel.

The piles, all 2,600 of them, are each fifty-four inches in diameter, and many are driven into the ocean floor more than one hundred feet. Each weighs 850 pounds per linear foot.

Cars travel at fifty-five miles per hour over the asphalt surface, thirty feet above the water. The roadway is twenty-eight feet wide to allow for two-way traffic even around a disabled vehicle.

Two tunnels allow shipping to move unrestricted through the Chesapeake Channel for the upper Chesapeake Bay and the Thimble Shoals Channel for Hampton Roads. The tunnels are identical other than a difference in distance of three hundred feet. Both are at least fifty feet below the surface of the bay. Cars actually travel through the tunnel ninety-three feet below mean low water.

At each end of the two tunnels there is a man-made island. Each one rises thirty feet above the surface and is eight acres,

approximately the size of Yankee Stadium or five football fields. Each island is built with approximatley 1.5 million tons of rock and 300,000 tons of sand.

The islands represent some of the most expensive real estate in the world. In 1964, each island cost about $5 million to build—$650,000 an acre. In addition to providing the base for approach ramps to the tunnels, the islands also serve as areas for garages, tunnel ventilation buildings, emergency euqipment and even a restaurant and a fishing pier.

Two fixed high-level bridges complete the CBBT. The North Channel Bridge, the larger of the two, is 3,793 feet long, including approaches. It offers 311 feet of horizontal clearance and 75 feet of vertical clearance. At its highest point, the roadway is 83.5 feet above the water.

The Fisherman Inlet Bridge provides 110 feet of horizontal clearance but only 40 feet of vertical clearance. Its 457-foot span allows access to the Intracoastal Waterway at the southern tip of the Eastern Shore.

On January 21, 1970, the USS *Yancey* was in a designated navy anchorage. Captain Dean R. Johnson, the commanding officer of the *Yancey*, ordered a regular anchor watch and had steam to the throttles in the engine room. "The purpose was so we could respond very quickly," he said.

About 1:00 a.m., a cold front bringing snow passed through the area. The winds changed from west-southwest to northwest and picked up to about thirty miles per hour, gusting to fifty. Soon afterward, the captain was notified that the *Yancey* was dragging anchor. A second anchor was dropped, but at 1:37 a.m., the stern of the 459-foot navy warship struck the trestle just south of the first island.

Philip Halstead, a CBBT supervisor, was in the tunnel control room on the first island that night. He saw the *Yancey* getting close to the span and at 1:30 a.m., he called the bridge-tunnel police and told them to stop all traffic on the bridge and call the Coast Guard—there was going to be a collision.

Several navy tugs and three Coast Guard cutters were dispatched, but only the USCG *Cherokee* arrived before the *Yancey* went completely through the trestle at 3:30 a.m. The *Cherokee* was not asked to assist. According to Captain Johnson, "Only after we went through could we use our engine without risking further damage." He offered no explanation.

Once the *Yancey* was clear of the trestle, it steamed to another anchorage about three thousand yards to the east. It left a four-hundred-foot gap in the span. *Yancey* had knocked five seventy-five-foot, sixty-five-ton, concrete deck units into the bay and damaged many others. No cars had been on the span and no one was injured.

Because extra deck sections and piles had been stockpiled during construction, the repair of the bridge was accomplished very quickly. The CBBT was only closed for about five weeks. In the meantime, the U.S. Navy used LSTs and helicopters to ferry cars and people across to the Eastern Shore and back.

Following this incident, the *Yancey* was deployed to the Mediterranean in the spring and returned to Norfolk, where it entered inactive service on October 1. On January 20, 1971, USS *Yancey* was decommissioned and towed to the James River, where it joined the National Defense Reserve Fleet until it was removed from the list in the fall of 1976. *Yancey* earned two battle stars for its operations in World War II and three for its Korean service. In addition, an Antarctic glacier, located in the Brittania Range, was named for it. It is now part of an artificial reef off the North Carolina coast.

The Chesapeake Bay Bridge Tunnel has since added a parallel span and is expected to add additional tunnels in the near future. It provides a structure where numerous variaties of fish feed and spawn. This, of course, attracts numerous varieties of fishermen, who travel from all around to fish at the CBBT.

There is one area that is a favorite to the locals. It isn't on any of the charts and you don't need a big boat to get out to it—it's just 3.5 miles offshore, just before the south island. In addition to the regular "structure," there are five seventy-five-foot, sixty-five-ton concrete deck units broken and scattered on the bottom. It's called "the *Yancey* wreck."

There were actually two other incidents in which vessels collided with the Chesapeake Bay Bridge Tunnel. The first occurred just before midnight on December 3, 1967. The CBBT was only three years old and in dire financial trouble. The 610-foot *Mohawk* was a fifty-four-year-old former coastal steamer that had been converted to a barge. On that night, it was anchored approximately one mile west of the CBBT when its anchor cable parted and it went adrift, pushed by thirty-mile-per-hour winds from the west.

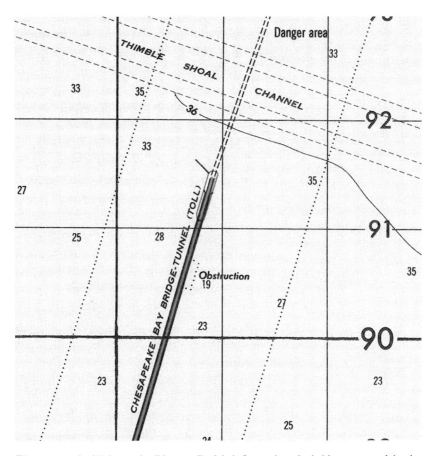

The area marked "obstruction" is actually debris from when the bridge was struck by the USS *Yancey*. *Courtesy of the author.*

The *Mohawk* first contacted the bridge just south of the southernmost island, and it hit with such force that it pushed one of the seventy-five-foot deck sections four feet toward the ocean, severing both electric and telephone lines. Then, driven by the wind and tide, it bounced south along the bridge span, hitting it another 163 times. As it bumped along in the choppy seas, it wiped out safety railings, two power transformers and damaged two additional trestle sections. One section fell four inches below the normal roadway level, and the other fell one inch. Fortunately, alert patrolmen with the Bay Bridge Police Department saw the *Mohawk* coming and stopped all traffic. As a result, there were no personal injuries.

All the damage to the CBBT was covered by insurance with the exception of $500,000. The Bridge-Tunnel Authority filed a $2 million damage claim against Indian Towing Company of New Orleans, the owners of the *Mohawk*. It took seven days to repair the damage and with each day the CBBT lost $2,800 in toll revenue. Also during that time, instead of driving 20 miles to get from Virginia Beach to the Eastern Shore, drivers had to drive the 150-mile detour.

Another incident, on September 20, 1972, involved the tug *Carolyn* and its tow, the *Weeks No. 254*. The tug and its tow were proceeding north in the Atlantic, bound for New York. Due to deteriorating weather conditions, the tug's captain sought refuge in the Chesapeake Bay. He had no navigational charts for the area so he had to depend on radio contact and visual guidance. The USCG cutter *Madrona* and a commercial tug, *Warrengas*, were standing by to assist if needed.

After passing over the Thimble Shoals Channel Tunnel, the *Carolyn* maneuvered to allow the *Warrengas* to take charge of the *Weeks No. 254*. The thirty-mile-per-hour winds, which gusted to sixty, forced the barge to ride at an angle off the *Carolyn*'s port stern, which in turn caused the tug to list thirty degrees to that side. At some point, a loose rope became tangled in the *Carolyn*'s propeller, causing loss of maneuverability. The tug's captain, fearing his vessel would capsize, requested evacuation assistance from the Coast Guard cutter. He shut off both engines and dropped the tug's anchor. The *Carolyn*'s anchor was not sufficient to hold both the tug and the barge, but it did slow the drift. The barge had its own remote-release anchor, but the *Carolyn*'s captain, although he was an experienced operator, did not release it. Unmanned barges are not required to have such equipment, so neither of the assisting vessels knew about it.

As the *Madrona* came alongside to transfer the tug's crew, the *Carolyn*'s captain, through some miscommunication, ordered the tug's anchor line cut. The *Madrona* immediately tried to get a line on the *Carolyn*, but the tug's captain was insistent that it was sinking. For the safety of your own vessel, you never tie a line to a sinking ship, so the *Madrona*'s crew tried to get possession of the towline between the tug and the barge. That was not possible because of the rough sea, nor were they able to secure a new line. The *Warrengas* may have been able to help, but it was never asked, so it just stood by in the area.

Out of control, the *Weeks No. 254* and the tug *Carolyn* smashed into the CBBT in the same location where the *Mohawk* and the *Yancey* had done so before. After about an hour, the *Carolyn* passed under the bridge and went aground on the beach, leaving the barge on the west side of the span, where the barge continued to pound against the pilings for another seven hours. The damage to the CBBT was listed as "extensive," and it took two weeks to complete repairs. The loss of revenue was conservatively estimated at $3.5 million only because of the time of year. Had the accident happened in July or August, the loss would probably have been $8 million. The *Carolyn* was undamaged and was moved to Norfolk for inspection on its own power. The *Weeks No. 254* was also undamaged, but its ultimate disposition is not recorded.

Part IV

War

Lady, Is This Your Purse?

World War I was certainly the first truly modern war. Military industrialists had developed new, more effective instruments of war —machines that could fly, float, rumble along the ground and even prowl beneath the waves. Submarines, like legendary sea monsters, rose from the depths of the sea and preyed upon helpless seafarers. Although all the modern navies had submarines, none used them as effectively as Germany. The German word *unterseeboot* actually refers to any submarine of any nationality, but *U-boat* has become synonymous with those of the German navy.

By the time the United States entered the conflict, the U-boats had earned quite a fearsome reputation. In fact, it was largely due to the sinking of the British passenger liner *Lusitania* by the *U-20* that brought America to arms. Of the 785 passengers who died when the ship was torpedoed on May 7, 1915, 128 were Americans. As a result, public opinion turned strongly against Germany and set the stage for a declaration of war.

With American men and equipment on the battlefield, things did not go well for the Germans. No longer having the military advantage, a plan was conceived to cut off the seemingly endless flow of supplies arriving from the United States. From May to October 1918, six

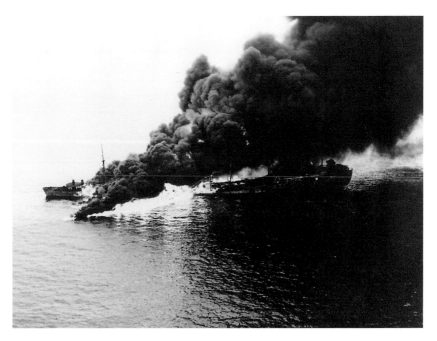

The tanker SS *Montana* burns after colliding with the SS *John Morgan* off Cape Henry on June 1, 1943. The *Morgan*, loaded with trucks, tanks and airplanes, sank and is a popular attraction for divers. *Courtesy of the National Archives.*

German U-boats operated off the North American coast from Cape Hatteras, North Carolina, north into Canada. Their goal was to interrupt the transportation of men and equipment at the source. Most vessels felt secure sailing so close to home, so they traveled unarmed and without escorts. This made them easy prey for the guns and torpedoes of the U-boats. In addition, the U-boats placed mines in the areas that were believed to be most heavily traveled by the transatlantic convoys. This strategy, however, yielded only one sinking—the USS *San Diego*, an armored cruiser, struck a mine and sank just ten miles off Fire Island, New York, on July 19, 1918.

Before dawn on the morning of August 18, 1918, the *U-117* was patrolling 125 miles off the Virginia coast when the lookout called the captain to the bridge. A target! In the moonlight, the U-boat's commander could safely observe his intended victim from a distance, knowing that his own vessel—with its low, dark silhouette—would not be noticed. Having determined that the wooden sailing ship was unarmed and thus, not a threat, the U-boat approached on the surface.

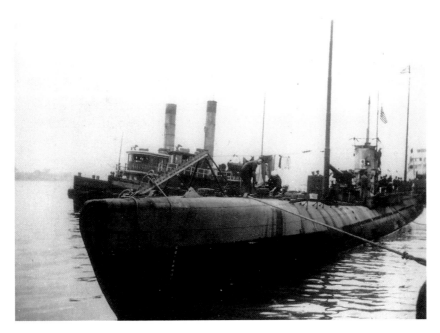

The German submarine *U-117* was brought to Norfolk after the war and was used for target practice off the Virginia Capes. *Courtesy of the author.*

Having learned that the 2,846-ton Norwegian barque was the *Nordhav*, transporting linseed oil from Buenos Aries to New York, a small group of German sailors was sent aboard. While one or two of these men assisted the Norwegians in launching the lifeboats, the others went to work placing explosives below deck. After everyone was safely away, the explosives were detonated and the *Nordhav* was destroyed.

That afternoon, the USS *Kearsage*, also on patrol, happened upon the *Nordhav*'s lifeboats and pulled the thirty-six men to safety aboard the warship. After a cursory search of the area, wanting to find the offending submarine, the *Kearsage* returned to Boston, where the Norwegians related their story to naval officials.

Also that afternoon, vacationers at the Virginia Beach oceanfront spotted a small open boat adrift approximately half a mile offshore. As they watched and waited over the next hour or so, the boat got closer. The spectators could see it was a lifeboat, but they could not see anyone in it. As the boat neared the beach next to Thirteenth Street,

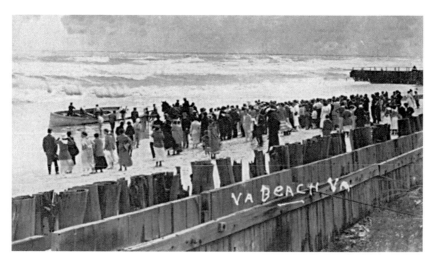

Curious spectators gather around when a lifeboat from the *Nordhav* washes ashore. *Courtesy of the collection of the Old Coast Guard Station.*

a group of men waded out into the surf, grabbed onto the boat and pulled it to shore. The name *Nordhav* was neatly painted on either side of the bow.

Dozens of curious onlookers gathered around in anxious anticipation, hoping that whoever was inside the small boat was still alive. Their concern turned to relief, and then bewilderment, when it was discovered that the lifeboat was empty of any passengers. What they did find, however, has never been explained. Inside the lifeboat was a large supply of food, several bottles of whiskey and some clothes. Also found was a lady's pocketbook—inside it was $1,000 in cash.

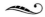

No April Fool

April 1 was no joke for the crew of the American steamship *Tiger*. The tanker had just completed a journey from Aruba and was waiting at the entrance to the Chesapeake Bay for a pilot boat to lead it through the protective minefield. After using a blinker light to signal for the

pilot, the *Tiger*'s lookouts spied a small craft approaching them from out of the darkness. Too late did they realize that it was a U-boat—150 yards distant on the starboard quarter. The tanker's master ordered evasive maneuvers, but too late. A torpedo exploded against the ship's hull thirty seconds later.

The *U-754*'s torpedo hit deep below the waterline. The force of the explosion caused heavy damage, and the tanker settled by the stern immediately. The engines and electrical power failed. The crew had no choice but to abandon ship. One crewman had been killed by the explosion, but forty-one others survived and made an orderly escape in three lifeboats. The attack took place shortly after midnight. Less than three hours later, the men in the lifeboats were picked up by the *YP-52* and taken to Norfolk.

At first light, additional vessels sent to the scene found the *Tiger* aground by the stern in sixty feet of water. The tug *Relief* tried to pull the tanker into shallow water, where its cargo (sixty-five thousand barrels of fuel oil) could be salvaged, but the ship would not budge and so was written off as a total loss and allowed to sink. Only its bridge, stack and masts remained above water. The 410-foot tanker

A U.S. Navy tug tries in vain to tow the SS *Tiger*. *Courtesy of the author.*

was dynamited and then dragged. Its wreckage is still indicated on charts, and it is very popular with recreational divers and fishermen.

The *U-754*, under the command of Kapitänleutnant Johannes Oestermann, had arrived off the Virginia coast only two days prior to sinking the *Tiger*. Almost immediately upon entering American waters, the U-boat found and attacked the tugboat *Menominee* and its three barges just a few miles to the north. Oestermann later sank the freighter *Otho* before he returned to France. He came back to the United States that summer only to find that American defenses had greatly improved. On July 31, 1942, the *U-754* was bombed and sunk north of Boston, Massachusetts. The entire complement of forty-three officers and men were lost.

General MacArthur's Day

On December 10, 1941, Germany declared war on the United States of America, and three weeks later, five German U-boats were dispatched to the American coast. The plan was to sink so many ships that, from shore, the echoes of the explosions would sound like the crescendo of a kettle drum. The initial assault was codenamed "Paukenschlag" (Operation Drumbeat).

The drum roll started when Kapitänleutnant Reinhold Hardegen, commander of *U-123*, attacked and sank the Panamanian tanker SS *Norness* on January 14, 1942. The attack took place at 1:20 a.m. just sixty miles off Montauk Point, Long Island (only one hundred miles from New York City).

At the end of two weeks, the five U-boats of Operation Drumbeat had destroyed 150,000 tons of Allied shipping and caused the death of almost five hundred seamen. By March, ships were being sunk at a rate of one every eight hours and, amazingly, there were never more than six U-boats in American waters at the same time.

In April 1942, the USS *Roper*, a "four-stacker" (World War I–era destroyer), found the *U-85* while patrolling off Cape Hatteras. The destroyer attacked the U-boat, sinking it with depth charges. Most

of the Germans escaped from the submarine but were killed when the *Roper*'s commander continued to drop depth charges in the area. Twenty-nine bodies were recovered, and after being searched and photographed, they were given a military burial in an American veterans' cemetery in Hampton, Virginia.

The German strategy changed. Something had to be done to make the Americans feel vulnerable at home. A direct assault by the German military was out of the question, but it was determined that a few well-trained saboteurs could do substantial damage to the American infrastructure. A plan was devised to send three U-boats to the United States. In addition to the regular load of torpedoes, each would carry a team of five English-speaking saboteurs.

One team would be unloaded on the coast of New York. Another would go ashore on the southeastern cost of Virginia and the third team would be delivered to the Florida coast. Each team would carry millions of dollars in counterfeit money and small explosive devices hidden inside pieces of coal.

The fifteen men would fan out, spend the money in an effort to disrupt the economy and spread about the pieces of coal so that they might end up in a home, a train or a boiler. As a result, the American people would feel threatened by the direct effects of the war and insist that their troops stay home instead of going overseas.

The U-boat to New York and the one to Florida both completed their missions, but vigilant lookouts soon apprehended the Germans. Most of them were executed.

The submarine that was scheduled to come to Virginia didn't sail because there was doubt as to the loyalty of one of the saboteurs. In order to achieve the maximum effect of the attack, it was imperative that some sort of disruption occur in the mid-Atlantic states.

Late in the afternoon of May 19, 1942, the *U-701* sailed from the French port of Brest. The German commander, twenty-nine-year-old Kapitänleutnant Horst Degen, had been given a special mission: to place underwater mines at the entrance of the Chesapeake Bay. Before leaving port, three magnetic mines had been loaded into each of the U-boat's five torpedo tubes. The mines were similar in shape to a torpedo, but only a third as long.

The *U-701* arrived at its assigned position on June 12, 1942. Listening in on a local radio broadcast, Degen learned that it was a

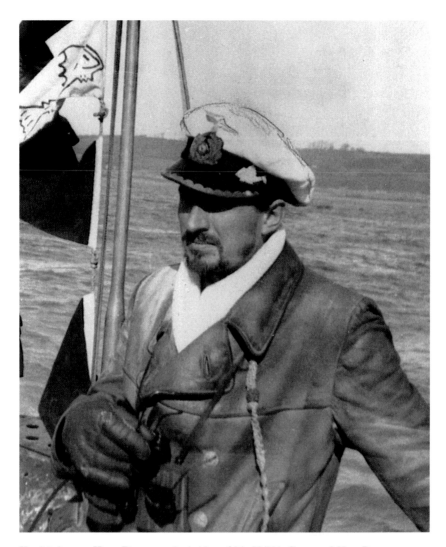

Kapitänleutant Horst Degen on the bridge of his *U-701*. *Courtesy of Horst Degen.*

day designated as "General MacArthur's Day." Degen considered his mines as appropriate gifts to celebrate this impromptu holiday. His orders were to remain submerged at the entrance to the Chesapeake Bay for twenty-four hours, observing ship traffic in order to determine the ideal place to set the mines. This meant that the U-boat had to lie on the bottom at a depth of only thirty-six feet. The bridge deck would only be a few feet below the surface.

Navigational charts of the area showed a big bank coming down from Cape Charles, blocking the direct entrance into the bay from the Atlantic. After meeting with his officers, it was agreed that there was only one possible passage into the bay and that was where the mines would be set.

After dark that night, the *U-701* slowly approached the coast of Virginia Beach. As the submarine turned north along the coast, the German lookouts could clearly see cars and even people unsuspectingly enjoying their summer vacations. As the brightly lit Cape Henry lighthouse came up on their port side, the U-boatmen prepared for their mission.

Shortly after 1:00 a.m., a trawler passed directly across the path of the submarine. The vessel, heading out to sea, was blacked out and seemed to be guarding the entrance to the Bay. This was the first time the Germans had seen anything that indicated that they were in an off-limits area. The trawler passed within 150 yards of the U-boat without seeing it. Degen waited until the ship was well to the east before proceeding.

The submarine moved slowly across the channel. Every minute, the order was given from the bridge to drop a mine. After being forced from the torpedo tubes, the mines fell to the bottom, where they would lay dormant for sixty hours. This allowed plenty of time for the U-boat to be safely away. After that, a ship passing over the mine would produce a magnetic contact in the detonator and set off an explosion.

With half of his payload discharged, Degen turned his boat around and made a second pass. Again the U-boat had to yield to the patrolling trawler. This time, concerned that the American sailors might hear the chugging of the submarine's diesels, Degen switched to the electric motors and slipped past his opponent. By 2:00 a.m., the job was complete and the *U-701* turned to the open ocean.

At dawn the U-boat submerged. The day was spent loading the reserve torpedoes into the tubes. A radio message from Admiral Donitz directed the U-boat to the area off Cape Hatteras. The submarine surfaced again at dusk and proceeded to that area.

About midnight, preparations were made for bringing in two additional torpedoes that were stored in pressure-tight tubes outside the U-boat's hull. This was a difficult operation, but one that the men of *U-701* had practiced many times. Frames were set up, and the torpedoes

were pulled out of the tubes. The front hatch was opened and one torpedo was gently coaxed through the narrow hatch. Then the same procedure was repeated at the stern. This time something jammed, and the torpedo was stuck half in and half out. Degen was near panic as the sun became visible on the horizon. His U-boat could not submerge with a hatch open and a dozen men on deck. Fortunately for the Germans, there was no aircraft activity that day and all went well.

Once below the surface again, the submariners worked till noon getting things back to operational readiness. Still short of Hatteras, the decision was made to surface again and proceed at full speed. A quick look through the periscope revealed no enemy activity so Degen carried out his plan.

It wasn't long before an airplane approached and forced the U-boat to crash dive. At a depth of 150 feet, the *U-701* was shaken by depth charges exploding close by. There was no second attack.

On the evening of June 15, a small convoy was entering Lynnhaven Roads in a single column. Without warning, there was an explosion on the starboard side of the tanker SS *Robert C. Tuttle*, the fifth ship in line. The ship's engines were stopped and the forward compartments quickly flooded. Three lifeboats were launched, and all but one of the forty-seven men aboard escaped and were rescued within fifteen minutes and taken to Little Creek, Virginia. The *Tuttle* sank by the head in fifty-four feet of water. The mine had done its job—the tanker's back was broken just aft of the midship house.

The *Tuttle*, carrying 100,000 barrels of crude oil, was in flames. All attempts to fight the fire with water and foam were unsuccessful. About midnight, two tons of dry ice in twelve-inch blocks were dropped into one hold, and the fire in that area quickly darkened. It had been an experiment, but it had worked, and all the fires were extinguished within two hours after the first application. A total of five tons of ice were used. The *Tuttle* was eventually salvaged and returned to service.

Following one thousand yards behind the *Tuttle* was another tanker, the SS *Esso Augusta*. When the master of that ship saw the explosion on the *Tuttle*, he signaled the engine room for full speed and ordered the wheel hard right. All hands went to battle stations.

Within thirty seconds after the *Robert Tuttle* was hit, a second explosion occurred three hundred yards off its port bow. There was no

vessel in that area. Perhaps the underwater turbulence had detonated another of Degen's mines. The *Esso Augusta* continued to zigzag in the area while numerous planes and surface ships dropped depth charges. Everyone was convinced there was an enemy submarine in the area.

Almost an hour later, the *Augusta* was rocked by a violent explosion ten yards off the ship's port quarter. The *Augusta*'s engines were shut down and the crew went to work assessing the damage. The tanker's rudder had been blown off by the explosion. The ship drifted seaward until navy tugs arrived and brought the crippled vessel into Lynnhaven Roads.

One of the convoy escorts was the destroyer USS *Bainbridge*. Almost immediately after the first explosion, the *Bainbridge* began searching for the offending U-boat, occasionally dropping depth charges in hopes of scaring the enemy away. One of the explosives dropped by the destroyer was apparently very close to one of the mines. A tremendous column of water rose up behind the startled men on the *Bainbridge*, causing damage to the vessel's propeller and rudder. The destroyer had to cease its operations and return to port.

Several miles to the south, another warship, the British trawler HMT *Kingston Ceylonite*, was escorting the last ship in the convoy. Believing that the convoy was under attack, the *Ceylonite* abandoned its charge and raced to the area off Virginia Beach. As the trawler approached, other vessels in the area signaled a warning that there might be mines. The *Ceylonite* did not have time to respond before it was literally blown out of the water. The ship was gone in three minutes. Two officers and eighteen men were killed.

By the next day, it was determined that enemy mines had been responsible for all the losses, and mine sweepers were called in from Yorktown. The area was divided into three sections to be swept, but due to some confusion, one area was checked twice and another area was not cleared at all. On June 17, the "all clear" was given and regular traffic was resumed into the Chesapeake Bay. At 7:45 a.m., the SS *Santore* left the bay to join a southbound convoy and struck a mine. The explosion tore a giant hole on the collier's port side and the vessel rolled over ninety degrees almost immediately. It was not possible to launch lifeboats so the forty-three survivors were forced to jump into the water, but they were quickly rescued by escort vessels and taken to Little Creek. Three men perished.

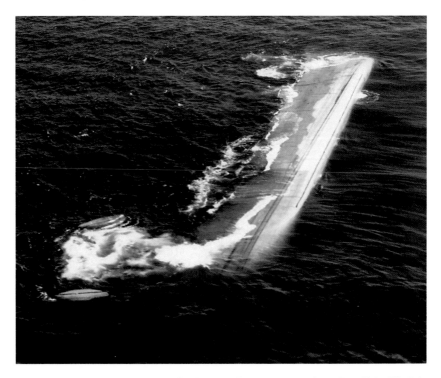

The SS *Santore* rolls over and sinks after hitting a German mine a few miles off the Virginia Beach coast in June 1942. *Courtesy of the author.*

Meanwhile the *U-701* had reached its new patrol area off Cape Hatteras. Degen received a radio message from Donitz congratulating him on his successes. The German submarine continued hunting but was constantly harassed, although unknowingly, by a small Coast Guard patrol boat, the *YP-389*. The sentinel was patrolling the same area as the U-boat. Degen decided he must destroy it.

On the night of June 19, 1942, the *U-701* maneuvered to a position astern of the patrol boat on an identical course. Invisible in the darkness, the Germans slowly closed in on their prey. Only a few hundred yards away, Degen altered his course slightly and opened fire. Every weapon on the U-boat blazed away at the *YP-389*. Very few rounds missed, and there was no return fire.

In no time the small vessel was in flames, and Degen called off the attack. *U-701* left the area in search of bigger game. Miraculously, only six men aboard the *YP-389* were killed.

While part of a thirty-one-ship convoy sailing from Lynnhaven Roads to Key West, Florida, the tanker *British Freedom* was torpedoed by the *U-701* off the coast of North Carolina on June 27, 1942. The ship was immediately abandoned by its entire fifty-five-man crew, but after fifteen minutes, the master and chief officer reboarded the vessel to assess the damage. Finding his ship to be seaworthy, the master then ordered the rest of the crew to return and the tanker was escorted back to Norfolk for repair.

At 10:00 a.m., with heavily armed escort vessels nearby, Kapitänleutnant Horst Degen ordered his boat to periscope depth at a position ahead of the approaching convoy and waited there for a target to cross his path. An hour later, he fired two torpedoes at the *British Freedom*. The first missed, but the second torpedo struck the tanker just forward of the bridge on the starboard side. The *U-701* quickly made for the safety of deeper waters.

The fleeing submarine was detected by the escort yacht *St. Augusta*, which attacked with depth charges until sonar contact was lost. Two hours later, the little ship made contact again and dropped more depth charges. Again the *U-701* slipped away. The submarine was found and attacked a third time by the persistent escort. This time, the explosions were so close to the U-boat that gauges in the control room were shattered. Still, Degen managed to escape.

The *British Freedom* was returned to service after being repaired. On January 14, 1944, the tanker was again torpedoed. While sailing in convoy *BX-141* from New York to Halifax, Nova Scotia, the ship was sunk with the loss of one crewman. Its master, Frank Llewellyn Morris, received the King's Commendation for brave conduct on this occasion.

After being damaged in his attack on the *British Freedom*, Degen had mechanical trouble with the air purifier on his *U-701*. As a result, it was necessary for the U-boat to surface frequently to ventilate. However, this did not prevent the submarine from sinking the SS *William Rockefeller* on the twenty-eighth. There were no casualties. The fifty survivors were taken to Cherry Point, North Carolina.

On July 7, 1942, a plane from the 396th Bombardment Squadron was patrolling off the North Carolina coast when the pilot, Second Lieutenant Harry Kane, noticed a U-boat on the surface about five miles away. As he approached, the *U-701* crash dived. When the *A-*

29 was over the spot where the U-boat had gone down, three depth charges were released. All three appeared to hit.

As the plane circled overhead, huge air bubbles rose to the surface. As the airmen watched, a man popped up in the middle of all the oil and bubbles. Soon other men were seen in the water. Lieutenant Kane and his men were certain of their success. While the plane's radio operator transmitted every detail of the attack, Kane continued to fly over the survivors. Four life vests and a rubber raft were dropped to the men.

There was a Coast Guard vessel only five miles away, and when he sighted it, Kane dropped a smoke flare to mark the area and then flew to alert the vessel. When the plane returned to the approximate area, the crew could not find the men in the water. Kane remained in the area until the Coast Guard boat was directly below and then set off to search for the survivors of the U-boat.

It was fifty hours before the U-boatmen were rescued by a PBY, sixty miles from the position given by Kane. Of the nearly thirty men who had escaped, only seven remained alive. All seven survivors were exhausted, hungry and thirsty, and two of them seemed delirious when they were picked up by the plane. Kapitänleutnant Degen was more badly injured than the rest of his men. Unconscious at times, his loyal crewmen had taken turns holding his head above water.

The men were brought to Norfolk and turned over to Naval Intelligence. Interrogation was begun within three hours after they had been rescued. Although his captors believed they had obtained vital information from the Germans, Degen and his men never said a word about their operation off the Virginia Beach coast. That information was not obtained until many years after the war.

One morning, during an interrogation, Degen was introduced to Lieutenant Kane. Kapitänleutnant Degen painfully pulled himself up from his wheelchair, faced Lieutenant Kane and saluted, congratulating the pilot on such a good attack. Kane assured the German that everything possible had been done to try and rescue the submariners, but no one anticipated the effects of the Gulf Stream.

After the war, Degen and Kane stayed in contact and became close friends. The location of the *U-701* remained a mystery for many years, but with Degen's help it was located off the North Carolina coast. It was Horst Degen's wish that the wreck, the final resting place of many

of his comrades, be treated with respect. Fortunately, he passed away before the souvenir hunters found and desecrated the site.

The wreck of the *Santore* was destroyed by the USCG cutter *Gentian*. The remains are spread across a wide area in about sixty feet of water. One of the large bronze propellers has been salvaged, but the other still remains with the wreckage.

Not much is left of HMT *Kingston Ceylonite*. The wooden hull is long gone, but there are still traces of the engine and the boiler in fifty-five feet of water. It is a popular recreational dive attraction.

The Cape Henry Wreck

On July 14, 1942, convoy *KS-520* left the Chesapeake Bay and headed south for Key West, Florida. Nineteen merchant ships of all types and nationalities were escorted on their journey by two destroyers, two patrol boats, two Coast Guard cutters, a Canadian corvette and a blimp. Several aircraft were also in the area, ready to attack quickly should a U-boat be detected in the area.

Indeed, a U-boat was in the area. Nearby, Kapitänleutnant Hans-Deiter Heinkicke watched the approaching ships through the periscope of the *U-576*. He cautiously stalked the convoy, carefully working his way closer inside the circle of escorting warships. At 6:20 a.m., the German commander fired a spread of four torpedoes at the unsuspecting merchantmen. Proper procedure then called for his crew to flood the submarine's forward tanks to compensate for the sudden and significant loss of weight. Someone, however, made a mistake. Perhaps he turned the wrong valve or simply miscalculated, but as a result the *U-576* popped to the surface like a balsa raft, right in the midst of the surprised convoy.

Almost at once, two planes dropped from the sky and attacked the U-boat with depth bombs. Before the submarine could get below, the naval armed guard aboard the *Unicoi* opened fire with that ship's five-inch gun, scoring a direct hit on the stern of the U-boat. The *U-576* was seen to turn sharply and list to starboard. Shortly thereafter,

The SS *Chilore. Courtesy of the author.*

the destroyer *Ellis* made sound contact and continued the attack with several patterns of depth charges. Thick black oil, bubbles and debris rose to the surface. The U-boat was lost with all hands.

In the meantime, Heinkicke's torpedoes were finding their marks. The collier *Chilore*, an American ship, was the first to be hit. The convoy commander, Captain Nichols, watched as the *Chilore*, the lead ship in the second column, took the torpedo on its port bow, lost headway and began taking water. Thirty seconds later, Captain Nichols's own ship, the tanker *J.A. Mowinckel*, was also hit on the port side. The tanker shuddered from the explosion, which tore a twenty-by-twenty-foot hole in the stern and disabled its steering gear. One crewman was killed and twenty others injured. No one aboard the *Chilore* was hurt.

As the rest of the ships in the convoy began to scatter and the attack on the *U-576* began, a third torpedo struck the small Nicaraguan freighter *Bluefields*. The freighter sank in only four minutes. Its entire crew somehow managed to abandon ship safely and was picked up by the USS *Spry*. Heinkicke's aim had been good—three hits from four torpedoes. One ship was sunk and two others damaged.

With the U-boat destroyed and the vice commodore now in command, the convoy regrouped and continued on its original course. Captain Nichols made the decision to take the two damaged ships into the shallow water of Hatteras Inlet, where temporary repairs could be made. The *Spry* would escort them. The area around the inlet had been seeded with mines several months before to defend against possible enemy invasion. The existence of this minefield was clearly shown on "Notice to Mariners #275," a communiqué given to all American ships. Unfortunately, although the *Mowinckel* was under contract with Standard Oil of New Jersey, it sailed under Panamanian registry and so did not receive this important notice. Even though Captain Nichols, a retired naval officer, was convoy commander, he did not have a ship of his own, so he did not receive the notice either. Captains Nichols ordered the ships to proceed into the inlet on course 315 degrees.

There were three small patrol craft that were to watch for U-boats outside the protective ring of mines and also to warn Allied vessels should they venture too close. On this afternoon, *PC462*, *PC463* and *PC480* were assigned this duty. *PC463* had been dispatched away from its station to hunt for a possible enemy submarine south of Cape Hatteras. The *PC462* was off carrying fuel to another patrol boat that was in need. As the two damaged ships and their escort approached within eight miles of the minefield, they passed the third patrol boat, *PC480*. The patrol boat, seeing the *Spry*, presumed that everything was in order and said nothing in the way of a warning.

Not long after the three ships had passed the *PC480*, a blimp observed the situation and tried to alert the unsuspecting ships of their danger by dropping smoke flares. Captain Nichols took this to be a warning that U-boats were in the area and ordered additional lookouts. The officers of the *Spry* began to realize their predicament and attempted to contact the *Mowinckel*. The tanker did not reply so the *Spry*'s commander, a junior officer, remained on course and said nothing more.

By this time, it was almost dark, and the ships were nearing the safety of the inlet. Suddenly, the sea erupted around the *Chilore* as that ship struck first one mine, then a second. Then the *Mowinckel* struck a mine. Believing that they were again under enemy attack, Captain Nichols ordered both ships abandoned. Even with the twenty

While being towed to Norfolk, the SS *Chilore* sank off Cape Henry. It is now referred to as the "Cape Henry Wreck." *Courtesy of the author.*

injured men, the *Mowinckel* was abandoned without incident, but panic aboard the *Chilore* resulted in one of the lifeboats being overturned. Two crewmen were drowned.

From the south, *PC462* hurried to the scene, frantically signaling a warning to the *Spry*, which obediently turned and followed the smaller boat to open water. Unable to be of assistance to the two sinking ships, the *Spry* steamed off to rejoin convoy *KS-520*.

PC462 took control of the situation and helped with the reboarding of the *Mowinckel* and the *Chilore*. Both ships were anchored for the night. During the next two days, several mines were cleared away to allow the vessels safe passage to the beach. Two tugs were sent out to bring the crippled ships to shore, but as the tug *Keshena* was making ready to tow the tanker, it struck a mine that had been missed. It went down in twelve minutes, taking two of its crew to their graves.

The two ships were finally brought to shore and repaired to the point that they could be taken to Hampton Roads for additional

work. After being refloated, the *Mowinckel* drifted while at anchor and struck yet another mine. Still, it did not sink. The battered tanker was brought into Norfolk on July 25, but it was not returned to service until March of 1943. The *Chilore*, having survived mines and torpedoes, capsized in shallow water at the entrance to the Chesapeake Bay. It was not salvaged.

The 550-foot, 8,310-ton *Chilore* was built in Alameda, California, in 1922. To prevent the wreck of the collier from becoming a hazard to navigation, it was dynamited and then dragged to scatter the debris. It has become a very popular fishing spot known to the locals as the Cape Henry Wreck.

Part V
Flotsam and Jetsam

"Flotsam" is what is found floating after a ship wrecks or sinks. "Jetsam" refers to things deliberately thrown overboard, or jettisoned, to prevent a ship from wrecking or sinking.

This chapter is a chronological collection of accounts of incidents that, because they were so commonplace, didn't receive much attention. All headlines that are asterisked come from the *New York Times*.

SUPPLY SHIP LOST
May 1697
A small British sloop, HMS *Swift*, ran aground on the beach south of Cape Henry. The vessel was a total loss, but its stores were recovered and eventually sent back to England.

PIRATES CAPTURED
April 29, 1700
After a seven-hour running battle with the British guard ship, HMS *Shoreham*, the pirate vessel *La Paix*, its masts shot away, went aground in Lynnhaven Bay just west of Cape Henry. The pirate captain, Lewis Guittar, threatened to blow up his ship and his hostages if he and his crew were not given clemency. The pirates were taken to England for trial. The *La Paix* was salvaged in November and sold.

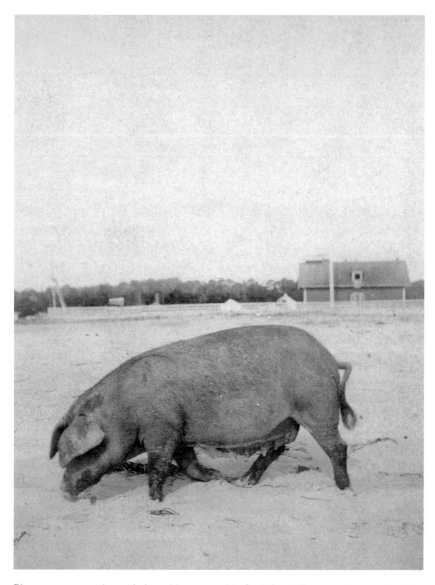

Pigs were commonly carried on ships to provide fresh food. The ones that survived the wrecks became feral and spawned a large population that became troublesome to the local community. *Courtesy of the collection of the Old Coast Guard Station.*

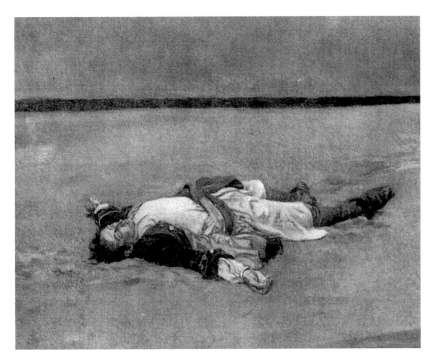

A body on the beach. Photograph by Howard Pyle (1853–1911). "Pirates Used to Do That to Their Captains Now and Then," in *Harper's Weekly*, 1894.

MORE PIRATES
July 1720

Eighteen bodies washed ashore near Cape Henry. Some of them were tied back to back, while others simply had their hands tied behind their backs. One man, who because of his clothing was supposed to be the captain, also had his feet tied together.

WARSHIP AGROUND AT CAPE HENRY
September 1806

Damaged in the "Great Coastal Hurricane of 1806," a British man-of-war drifted under jury sails for twenty-three days before beaching at Cape Henry. The seventy-eight-gun vessel, HMS *L'Impeteux*, had been captured from the French the previous year.

*LOSS OF THE SHIP *EVA DORTHEA*
December 9, 1857

Two hundred and sixty passengers were safe after the *Eva Dorthea* ran aground at Cape Henry. The ship, sailing from Bremen to Baltimore, was a complete loss.

*THE AFFAIR AT CAPE HENRY
October 16, 1861

A government schooner went aground in Lynnhaven Bay near Cape Henry. All those who made it to shore were taken prisoner by Confederate forces. The schooner was carrying stones to be dumped in the channel near Cape Hatteras, North Carolina, as part of the Union blockade of Confederate ports.

*FROM FORTRESS MONROE
March 28, 1864

Two schooners wrecked on the shore near Cape Henry and were total losses. The *Beulah* was bound for Fortress Monroe and the *Alexander Young* for Port Royal, Jamaica. Both vessels were carrying coal to their respective destinations.

*A SUNKEN SCHOONER RECOGNIZED—ALL HANDS PROBABLY LOST
November 29, 1873

Cargo and debris washed ashore near the Dam Neck Mills Life Saving Station. Information recovered from documents indicates it is the remains of the schooner *St. Mary* from Philadelphia. The ship's co-owner, Captain McDonnell, traveled from that city to take possession of items that had been salvaged. It appears from examination of the wreckage that the *St. Mary* had been rammed by another vessel while at anchor. The schooner's other owner, Captain Steelman, was master of the sunken vessel. His body and those of the crew are unaccounted for. The body of the ship's cook washed to shore with the debris.

*A BODY WASHED ASHORE AT CAPE HENRY
April 18, 1875

A report from the Life Saving Station at Cape Henry states that the body of a man was found washed up on the beach two miles north of the station. The man is described as being about twenty-five years of age, five foot six inches tall, with short, dark hair. He was well dressed and in the pocket of his tweed suit was a copy of the *New York Herald* of March 10. The fishermen who found the body buried it on the beach.

*MARINE DISASTERS
May 17, 1878

The schooner *J. Burley* went ashore in Lynnhaven Bay and was totally destroyed. The cargo of coal was salvaged. The vessel's first mate, A. Gavitt, drowned while trying to swim to shore.

*DISASTERS TO VESSELS
March 4, 1879

The Norwegian barque *Admiral* was stranded overnight one mile south of the False Cape Life Saving Station. The ship's master, Captain Jensen, and the crew of fourteen were rescued by the surfmen. The barque had been at sea for forty days, sailing in ballast from Dunkirk, France, for Baltimore, Maryland. The *Admiral* was a total loss.

*DISASTERS TO VESSELS
September 27, 1880

The two-masted British schooner *Lizzie and Emma* burned and sank in Lynnhaven Bay during the night. It was bound from Norfolk, Virginia, to Kingston, Jamaica, with a cargo of shingles. Its master, Captain D. McPhee, the crew of five and the sails were saved.

*WASHED ASHORE ON THE COAST
April 2, 1881

A telegram from the signal officer at Cape Henry: "No. 6 man of Life Saving Station No. 1, yesterday about 7:30 P.M., found a dead man washed ashore about three-fourths of a mile north of this office. The body is in an advanced stage of decomposition. It had on the right arm a tattooed ring around the wrist, with a flower pot above;

Shipwreck victims were commonly buried in the dunes after their bodies washed ashore. *Courtesy of the author.*

on the left arm a star, with a design of a woman with arms held up and legs diagonally crossed. The appearance of the clothing would indicate that the dead man was a member of the Navy."

*FOUND DEAD IN THE WATER
June 16, 1881

Responding to a report that a body had been discovered in the surf three miles north of the Cape Henry Life Saving Station, a surfman from that station went to investigate. After walking one quarter of a mile, he found a seaman's cap of the German frigate *Nymphe*. The name "Zieze" was sewn to the inside of the cap. Another two miles up the beach, in the surf, was the body. The corpse was so badly decomposed that the head and hands were nothing but bone. The fishermen who

found the body had recovered identification papers belonging to Rigby Lanburn Hubbard. It was found that R.L. Hubbard was the master of the schooner *David E. Wolf.* On February 25, the schooner had been sunk following a collision with a British steamer. The incident occurred near York Spit in the Chesapeake Bay.

*DISASTERS TO VESSELS
October 7, 1881

The schooner *William Walton* from Philadelphia to Norfolk with a cargo of coal sunk in Lynnhaven Bay during the gale of Tuesday night.

*A MESSAGE IN A FLOATING BOTTLE
August 8, 1882

After arriving in Norfolk, Captain Godfrey of the *Daisy,* a wrecking schooner, read the following note found floating in a bottle near Cape Henry: "The bark Flying Fish is about to sink off Cape Henry. It is night and no help is in sight. Our last chance is gone. Lyman."

Many ships disappeared without a trace. A message in a bottle could give some explanation as to what happened. *Courtesy of the author.*

SCHOONER LOST
January 26, 1884

The three-masted schooner *Albert C. Paige* grounded two and a half miles north of the Dam Neck Mills Life Saving Station while en route from Charleston, South Carolina, to New York City. The crew of six was saved. The schooner and the cargo of phosphate rock were a total loss.

*PICKED UP FROM THE SEA
June 25, 1885

A note in a bottle was recovered from the ocean six miles from Cape Henry. The message read as follows: "We are in a terribly [*sic*] storm just off Cape Henry, Va. U.S.A., and are fast sinking; schooner *Alice* of Queenstown, Eng.—Help. George A. Lilla, Captain."

*WRECKS ON THE VIRGINIA COAST
February 6, 1886

The schooner *Col. S.R. Razee*, with a cargo of lumber from Petersburg, Virginia, to New York, went aground in Lynnhaven Bay during a storm. It was a total loss. The crew remained in the half-flooded cabin all night and was rescued the next morning. One Norwegian crewman was drowned when he attempted to swim to shore.

*A SCHOONER AND CREW LOST
February 19, 1886

A ship that sailed from New York to Norfolk, Virginia, on February 1, and had not been heard from since, has been located. It was confirmed that a vessel, known to have sunk near Lynnhaven in a recent storm, was the *Anthea Godfrey*, Captain J.T. Riggin, master. Onboard with Captain Riggin were his wife, five daughters and four crewmen. All are presumed drowned. Riggin's family was making their first trip with him.

*THE *MAIR AND CRAMMER* LOST
April 8, 1887

It is determined that wreckage that has been washing ashore in Lynnhaven Bay is from the Pennsylvania schooner, *Mair and Crammer*. The schooner left New York bound for Norfolk, Virginia, on March

10 and had not been heard from since. The *Mair and Crammer* sailed with a crew of six, under the command of Captain John. R. Budd. All are presumed lost.

*VESSELS WRECKED
November 1, 1887

The Dam Neck Mills Life Saving Station reports the *Mary D. Crammer* aground near that location. The crew was saved but the schooner was a total loss. The schooner was en route from the James River to New York City.

SIX DIE IN SHIPWRECK
March 14, 1889

The *Agnes Barton* washed ashore one quarter of a mile from the Dam Neck Mills Life Saving Station. It was carrying phosphate rock to Baltimore, Maryland, from Rio de Janeiro, Brazil. The lifesavers were able to rescue four of the crew, including one man who had tied himself to the ship's mast. Five of the crew could not be saved, and the captain was washed out of the breeches buoy and drowned. The three-masted barque was a total loss. Much of the wood was salvaged and used to build a small church. The mast that the one seaman tied himself to was used to make the communion rail inside the church.

*BARKENTINE *JOSEPHINE* STRANDED
May 18, 1895

During the night the bark *Josephine*, bound for Baltimore from Rio de Janeiro, Brazil, went aground a mile and a half south of the Little Island Life Saving Station. The crew of thirteen was rescued in the surfboat. The schooner, valued at $166,140, and its $50,000 cargo of coffee were a total loss.

*STRANGE HAPPENINGS OF RECENT DAYS
January 2, 1896

This is a lengthy article about odd occurrences at sea. Two stories take place off the Virginia Beach coast. The first story tells of the steamer *Buckminster* passing the Cape Henry Lighthouse when the lookout spotted something in the water nearby. It was a hand rising out of the waves. The thumb and fingers were visible, the wrist and

arm were underwater. As the *Buckminster* approached, it was obvious that the arm was not attached to a body.

The second story came from the log book of the Nova Scotia barque, *Bertha Gray*. As it was passing a few miles off Cape Henry, a small boat was seen ahead. It was approximately twenty feet in length, American-built, painted white inside and out. As the *Bertha Gray* got closer, it was observed that the small, white boat was full of water and a body was floating in it.

*SCHOONER *A.D. LAMSON* SUNK
August 3, 1897

Bound from Baltimore to Charleston with a cargo of 426 tons of coal, the schooner *A.D. Lamson* sank near Cape Henry after being rammed by another vessel. The eight crewmen survived and got to shore aboard a lifeboat. There is no information about the vessel that struck the *Lamson*.

CAPE HENRY ADRIFT
August 25, 1901

The schooner *Cape Henry* was found adrift and unmanned off the beach at Cape Henry. There was no word of the crew.

*SIGNS OF STEAMSHIP WRECK
June 17, 1904

Surfmen at the Cape Henry Life Saving Station report that charred debris was washing ashore near that location. They were able to recover some cabin furniture, several empty five-gallon oil drums and a passenger check from the Ocean Steamship Company, Savannah, Georgia. The check was marked with the number 7,567. According to a spokesman for the Ocean Steamship Company, the check with that number was sold on May 24, but it could not be identified because the ship on which it was used, the *City of Memphis*, had reached its destination of New York and returned to Savannah without incident.

*CREW OF SCHOONER IS RESCUED
December 24, 1905

The *E.H. Moore* was stranded this morning one mile south of the Little Island Life Saving Station. The crew was rescued. The schooner,

bound from Norfolk, Virginia, to Wearneck, Gloucester County, Virginia, with tiles and shingles, was a total loss.

NAVY TUG DISAPPEARS, PRESUMED LOST
February 13, 1910

Two tugs, *Nina* and *Savage*, were attempting to exit the Chesapeake Bay in a heavy snowstorm. Captain Hand of the *Savage* determined the conditions were too severe, so he returned to Norfolk. The *Nina* continued and is presumed lost. After three days of searching by the U.S. Navy and the Revenue Cutter Service, there has been no trace of the *Nina* or its thirty-two-man crew.

*TIDE WRECKS A SCHOONER
September 20, 1911

The four-masted schooner *Stella B. Kaplan* was sailing out of Chesapeake Bay to Savannah, Georgia, when the wind stopped and the strong tide pushed the vessel onto the shoals. The *Kaplan* and its cargo of 1,600 tons of coal were a total loss. The crew of ten escaped in a lifeboat.

TALLAC STRANDED
February 24, 1920

The 235-foot *Tallac* (formerly *Simon J Murphy* and *Melville Dollar*) stranded eighteen miles south of Cape Henry and was a total loss. The vessel was en route from Colon, Panama, to Baltimore, Maryland, when the incident occurred. There were no injuries to the crew.

*TAKE SIX OFF TRAWLER
November 13, 1928

Battling heavy surf, the Coast Guard rescued Captain M. Shaderburg and five crewmen from the steam trawler *Ruth Mildred*. All are being cared for at the Little Island Coast Guard Station. The trawler, from Gloucester, Massachusetts, was a total loss. Eight months earlier, the *Ruth Mildred* was boarded and searched in Long Island Sound, New York, and Coast Guard officials found and destroyed a large amount of intoxicating liquor.

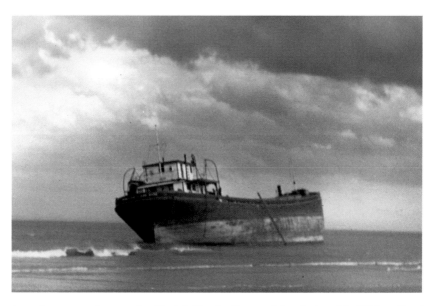

An unknown vessel aground at Virginia Beach. *Courtesy of the collection of the Old Coast Guard Station.*

*ELEVEN MEN ARE TAKEN OFF TRAWLER NEAR VIRGINIA BEACH—NEW YORK FISHING VESSEL SINKS
February 15, 1931

The Coast Guard reports that the eighty-eight-foot fishing smack *Beauty St. Joseph* sank six miles east of Cape Henry. The twelve crew members were taken aboard another fishing boat.

MARYLAND PILOT BOAT SINKS
December 1, 1938

The Maryland pilot boat *William D. Sanner* sank just west of Cape Henry after being struck by the British freighter, *Levernbank.* Formerly the luxury yacht *Carmina,* the 260-ton vessel has given up numerous "souvenirs" to local divers over the years.

TWO SHIPS COLLIDE OFF VIRGINIA BEACH
June 1, 1943

The tanker SS *Montana* collided with the liberty ship SS *John Morgan* in heavy fog. The *Montana* caught fire when the *Morgan* exploded, but it did not sink. The *Morgan,* on its maiden voyage, was sailing from

Philadelphia to Bandar Shahpour, Iran. Its decks were laden with Valentine tanks, Willis jeeps, Ford trucks, Caterpillar tractors, P-39 aircraft and thousands of small arms and munitions. The *John Morgan* was cut in two with the loss of sixty-eight men. The stern section sank in less than two minutes and is a very popular dive attraction, but not for beginners as it is deeper than one hundred feet.

BATTLESHIP RUNS AGROUND
July 18, 1950

The USS *Missouri* (BB-63) ran aground near the entrance to the Thimble Shoals Channel near Cape Henry. It took five attempts over the next two weeks for the battleship to be pulled free by ten tugs and four navy frigates working together. The grounding was the cause of persistent rumors that the ship could never exceed fifteen knots because its hull was cracked. The *Missouri*'s commander, Captain William Brown, was court-martialed as a result of the incident and never commanded another ship.

COMMERCIAL FISHING BOAT SINKS
March 16, 1975

The fishing boat *Doxie Girl*, of the Long Island Sea Clam Corporation, sank in a storm in sixty-five feet of water near the entrance to the Chesapeake Bay. Four men, including the vessel's captain, were lost.

The *Missouri* was not the first battleship to ground in Lynnhaven Bay. The USS *Michigan* did the same thing on November 26, 1914. *Courtesy of the U.S. Naval Museum.*

*2 HURT IN NAVY SHIP COLLISION
March 4, 1979

Two naval officers were seriously injured when the USS *Francis Marion* (LPA-249) collided with the Greek cargo ship MV *Starlight* in heavy fog two miles off Cape Henry at 8:42 a.m.

*BOAT WITH TEN ABOARD IS REPORTED SINKING
MARCH 25, 1989

At 9:30 p.m., the Coast Guard received a distress call from the fifty-two-foot sport-fishing vessel *Blue Goose*, battling rough seas and poor visibility five miles off the Virginia Beach coast. An hour later, the *Blue Goose* reported it was taking on water, and the ten occupants onboard were abandoning it. The Coast Guard advised everyone to remain onboard but received no acknowledgement. For the next twenty-four hours, three Coast Guard cutters, two navy ships and a Coast Guard helicopter searched the area but found no trace of the *Blue Goose*. With the water temperature in the forties, anyone who had gone overboard would have succumbed to hypothermia very quickly.

SAILBOAT SINKS OFF VIRGINIA BEACH
November 1, 1991

Four persons were rescued from their sinking sailboat by a Coast Guard helicopter.

GREEK SHIP AGROUND AT VIRGINIA BEACH
February 3, 1996

The Greek collier SS *Protagoras* dragged its anchor during an ice storm and ran aground in the Chesapeake Bay near Lynnhaven. It was refloated during the next high tide.

FISHING VESSEL CATCHES FIRE AND SINKS
August 13, 1997

The fishing vessel *Katye Marie* caught fire sixty-two miles east of Cape Henry. The two-man crew abandoned ship onto a life raft and they were soon rescued by a U.S. Navy Cyclone-class patrol boat, the USS *Shamal* (PC-13). The *Shamal* also extinguished the fire. The men were later transferred to the USCG *Point Bonita* (WPB-82347), which

The Greek ship *Protagoras* ashore near the Lynnhaven fishing pier. *Courtesy of the author.*

also took the *Katye Marie* in tow. The fishing boat sank approximately twenty miles from the entrance to the Chesapeake Bay.

U.S. DESTROYER RAMS SAUDI CARGO SHIP
February 4, 1999

Twenty-five miles off the Virginia Beach coast, the destroyer USS *Radford* (DD-968) collided with the *Saudi Riyadh*, injuring one sailor and causing $32 million damage to the warship. At the time of the incident, the *Radford* was circling a buoy to calibrate some electronic warfare equipment.

SMALL CRUISE SHIP RUN AGROUND TO KEEP FROM SINKING
November 8, 2007

The captain of the 207-foot *Spirit of Nantucket* ran the vessel aground to prevent it from sinking after striking a submerged object at 5:30 a.m. The accident occurred in a portion of the Intracoastal Waterway that passes through rural Virginia Beach. The *Spirit of Nantucket* was on a ten-day cruise from Alexandria, Virginia, to Charleston, South

Carolina, when the accident occurred. The guests quietly ate their breakfasts while waiting for the Coast Guard to arrive. Sixty-six passengers and crew were evacuated and were given accommodations at local hotels. There were no injuries and the ship was towed to Norfolk and repaired.

A Final Word

S hips have always played a vital role in the history of the world, from discovery to conquest to liberation to exploration to commerce to recreation. Tales of nautical adventures are still popular: the journeys of Sinbad, *Moby Dick* and *Master and Commander*. Maritime disasters continue to fascinate us: *The Poseidon Adventure*, the *Titanic* and the SS *Minnow*. Words and expressions relating to the sea are part of our everyday language: "washed up," "rudderless" and "sinking feeling."

The Reverend W.H.T. Squires (1875–1948) wrote several books, including three about Virginia. The first, *The Days of Yester-Year*, was published in 1928. The following year he wrote *Through Centuries Three*. In the third book, *The Land of Decision*, published in 1931, Squires wrote about Cape Henry's history and natural beauty. He also took the opportunity to wax poetic about the tragedy of mankind:

But the storms leave tokens. There are always wrecks at Cape Henry; broken spars, half buried in the drifts, and timbers covered with fungus, tossed upon the shore. The bulkheads of ships long lost lie, at low tide, half submerged like the ribs of some monster from the depths. Mournful the tale these relics might tell. Some master sought safety here, but the sea ran too strong, or the winds were too wild, or the billows too heavy, or the fog was too dense. Perhaps the pilot became panic-stricken, or the rudder snapped, or a nail started

or the master missed his reckoning. The cargo ship, and perhaps many of the crew, fell victims to the howling tempest.

There is something inexpressibly pathetic in wrecks. They lost their way, or missed their chance, and never came to port. Whether ships that sail the seas, or souls that go astray, whether the bride at the alter or the child that sobs on the street, a wreck, a blunder, a fatal mistake—how pathetic, and alas, how frequent!

Bibliography

Ashe, Dora Jean, comp. *Four Hundred years of Virginia, 1584–1984: An Anthology*. Lanham, MD: University Press of America, Inc. 1985.

Berman, Bruce D. *Encyclopedia of American Shipwrecks*. Boston: The Mariners Press, Inc., 1972.

Creecy, John Harvie, ed. *Princess Anne County Loose papers, 1700–1789*. Richmond, VA: The Dietz Press, Inc., 1954.

Defense Mapping Agency, Topographic Center. *CAPE HENRY*. Sheet 5757, Series V734, Edition 2-DMATC. Washington, D.C.: Defense Mapping Agency, Topographic Center, 1973.

Department of Transportation. Marine Casualty Report. *Collision of the Tug Carolyn and the Weeks Barge No. 254 With the Chesapeake Bay Bridge and Tunnel on or About 21 September 1972 Without Loss of Life*. Washington, D.C.: Department of Transportation, 1974.

Foss, William O. *The Norwegian Lady and the Wreck of the Dictator*. Virginia Beach, VA: Noreg Books, 2002.

Hydrometeorological Prediction Center (HPC). www.hpc.ncep.noaa.gov/research

Kyle, Louise Venable. *The History of Eastern Shore Chapel and Lynnhaven Parish 1642–1969*. Norfolk, VA: Teagle and Little, Inc., 1969.

Moore, Arthur R. *A Careless Word…A Needless Sinking*. Kings Point, NY: U.S. Merchant Marine Academy, 1984.

Mulligan, Timothy, ed. *Records relating to U-boat Warfare, 1939–1945: Guides to the Microfilmed Records of the German Navy, 1850–1945: No. 2.* Washington, D.C.: National Archives and Records Administration, 1985.

National Ocean Service Automated Wreck and Obstruction Information System, February 16, 1988.

A New Era Opens. A souvenir publication printed in limited edition for the opening of the Chesapeake Bay Bridge-Tunnel. Self-published, April 15, 1964.

New York Times Article Archive. www.nytimes.com/ref/membercenter/nytarchive.html.

Pouliot, Richard A., and Julie J. Pouliot. *Shipwrecks on the Virginia Coast and the Men of the Life Saving Service.* Centerville, MD: Tidewater Publishers, 1986.

Shomette, Donald G. *Pirates on the Chesapeake.* Centerville, MD: Tidewater Publishers, 1985.

Squires, W.H.T., Rev. *The Land of Decision.* Porstmouth, VA: Printcraft Press, Inc., 1931.

Turner, Florence Kimberly. *Gateway to the New World; a History of Princess Anne County, Virginia 1607–1824.* Easley, SC: Southern Historical Press, 1984.

United States Coast Guard. Commandant's Action. www.uscg.mil/hq/g-m/moa/boards/soyaatlantic.pdf.

———. Letter from Chief, Merchant Vessel Inspection Division to Commandant. www.uscg.mil/hq/g-m/moa/boards/thomastracy.pdf.

———. Mormackite. www.uscg.mil/hq/g-m/moa/boards/mormackite.pdf

Williams, Lloyd Haynes. *Pirates of Colonial Virginia.* Richmond, VA: The Dietz Press, 1937.